IMAGES
of America

THE CHESAPEAKE
AND OHIO CANAL

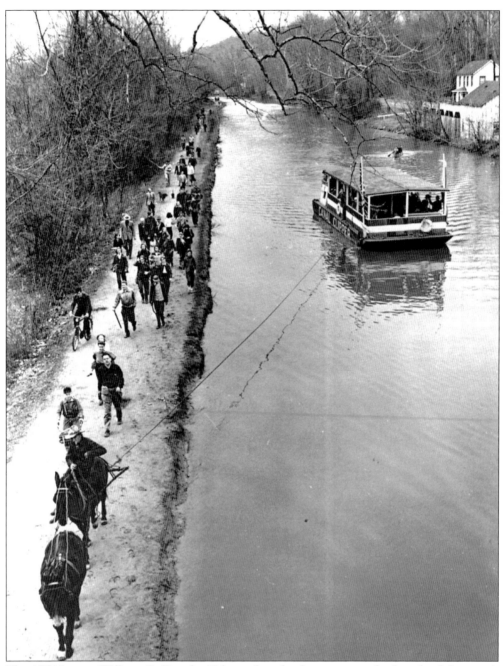

The 1954 Justice William O. Douglas Hike took eight days to cover the length of the canal. This is one of many photos taken along that historic walk. Note the mules pulling the *Canal Clipper* excursion boat along the towpath beside the hikers. (Courtesy C&O Canal National Historical Park Headquarters.)

IMAGES
of America

THE CHESAPEAKE
AND OHIO CANAL

Mary H. Rubin

ARCADIA
PUBLISHING

Published by Arcadia Publishing
Charleston SC, Chicago IL, Portsmouth NH, San Francisco CA

Printed in the United States of America

Library of Congress Catalog Card Number: 2003111927

For all general information contact Arcadia Publishing at:
Telephone 843-853-2070
Fax 843-853-0044
E-mail sales@arcadiapublishing.com
For customer service and orders:
Toll-Free 1-888-313-2665

Visit us on the Internet at www.arcadiapublishing.com

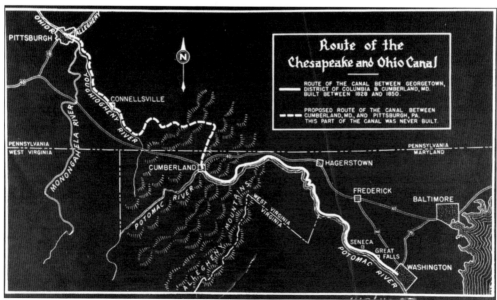

This map shows the route of the C&O Canal from Georgetown westward. The route to Cumberland, Maryland, was built but the remainder of the proposed route to the Ohio River in Pittsburgh, Pennsylvania, was never completed. The canal derived its name from this original intended route to connect Baltimore, Maryland, on the Chesapeake Bay with the Ohio River. (National Archives Map. Courtesy C&O Canal National Historical Park Headquarters.)

CONTENTS

ACKNOWLEDGMENTS

The author wishes to gratefully acknowledge all of the help and information provided by the C&O Canal National Historical Park Headquarters; their generosity in opening their collection to me was paramount to the success of this title. Photos and background research for the photos were in abundance, making it difficult to keep choices within the scope of this title! Also, both the Western Maryland Room of the Washington County Free Library and the *Maryland Cracker Barrel* magazine provided invaluable research information. I would like to thank Kay Rubin for her continued enthusiastic assistance in making various arrangements and helping gather many pieces of information and keeping photo inventories. Finally, my thanks to all those who have been so supportive of my previous titles documenting our region's past.

INTRODUCTION

The clip-clop of the mules' feet along the towpath, calls of "Hey-ey-ey Lock!" at all hours of the day or night, the gentle lapping of the water against the boats—all of these sights and sounds from past days of the Chesapeake and Ohio Canal are no longer part of everyday life but their legacy endures. Stretching from the mouth of Rock Creek in Georgetown west to Cumberland, Maryland, the Chesapeake and Ohio (C&O) Canal runs parallel to the Potomac River for 184.5 miles. The story of the canal is not just the history of the waterway trade; it is inextricably tied to the histories of the people and places that grew up around and thrived because of the canal and its operations.

George Washington first attempted to make the Potomac River a viable route to the west in 1785 with the founding of his Patowmack Company. The skirting canals that the company constructed around the Great Falls rapids at Harpers Ferry, Seneca, and Little Falls made 218 miles of the Potomac navigable. However, a great many hazards existed, and when work began on the Erie Canal in New York in 1817, discussions for a more dependable route west to the Ohio River that would link with the Mississippi began in earnest.

The Chesapeake and Ohio Canal Company was chartered by Maryland, Virginia, and Pennsylvania in 1828 to build a truly useful canal to the Ohio Valley. President John Quincy Adams turned the first spadeful of dirt on Independence Day, July 4, 1828, for what was hailed as the "Great National Project" to connect Georgetown to Pittsburgh. The canal would include locks, dams, and aqueducts, plus an engineering marvel tunnel that took 12 years to complete. The widest, deepest, and sixth longest canal in the nation was completed to Cumberland in 1850.

The canal created a total community of people and a way of life different from any other. Entire canal families lived and worked on their boats, traveling back and forth along the length of the canal. Many communities grew up around the canal and the commerce that it brought. Construction of the canal brought labor jobs to the region. Raw materials such as stone, cement, and lumber were in high demand, and farmers found a ready market for their produce. Cumberland coal became a cargo mainstay, and at the height of operations, there were more than 500 boats plying the canal.

After years of financial difficulties, competition from the railroads, and the Civil War, the canal went into receivership. In 1924, a flood finally brought the end of the canal, and it sat in neglect. The C&O came under the auspices of the United States government in 1938 and

was placed under the control of the National Park Service. Plans developed to use the canal bed to build a parkway through the region, similar to Skyline Drive in Virginia. However, in 1954, Supreme Court Justice William O. Douglas brought the public's attention back to the canal and the natural beauty of the region along the length of the towpath. His efforts saved the canal from imminent destruction and today the C&O enjoys status as a National Historical Park with many recreational and historical opportunities. Canal boat replicas ply the canal at Georgetown and Great Falls, all manner of outdoor enthusiasts find something special in the canal, and it is a treasure for history seekers.

Join author Mary Rubin in a look back at the Chesapeake and Ohio Canal as seen through photos of days gone by. Images from the C&O Canal National Historical Park Headquarters bring the canal back to life and illustrate the vital role it played in the growth of our nation. When experiencing the quiet towpaths and abandoned structures that remain today, take a moment to reflect on what a true marvel the canal really represents—it is doubtful that such an undertaking would even be considered in today's world of environmental impact statements. Join us now in a walk through history in this retrospective and remember the days of the C&O Canal!

One

GEORGETOWN TO
GREAT FALLS

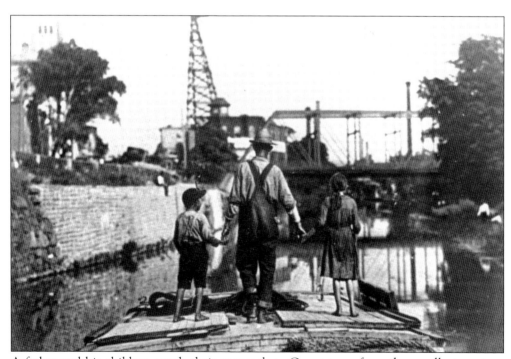

A father and his children watch their approach to Georgetown from the excellent vantage point of the top of their boat in this poignant photo. (Courtesy C&O Canal National Historical Park Headquarters.)

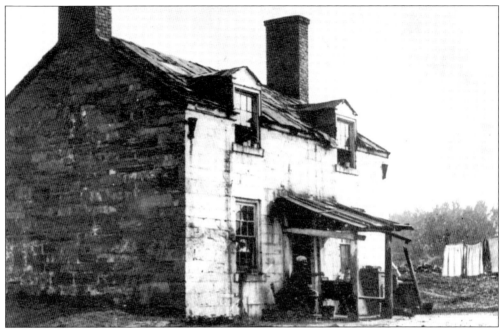

This is a photograph of Lockhouse B, *c.* 1860, at 17th Street and Constitution Avenue in Washington, D.C., on the Washington Branch of the canal. The branch linked the C&O at Georgetown with the Washington City Canal. A woman is on the small porch and laundry is hanging on the lines to the right. (Courtesy C&O Canal National Historical Park Headquarters.)

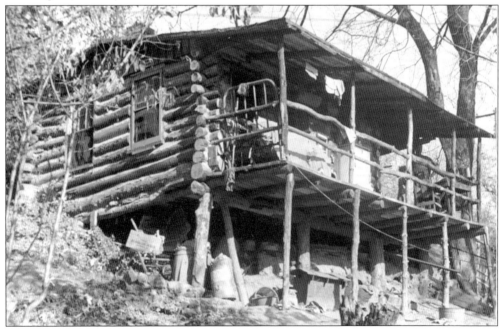

In the years after canal operations ended, dwellings along the canal continued to be occupied by private citizens. Louise Davis lived in this log cabin at 4519 Canal Road when this photo was taken on October 23, 1952. An area African-American church owned the private property. (Courtesy C&O Canal National Historical Park Headquarters.)

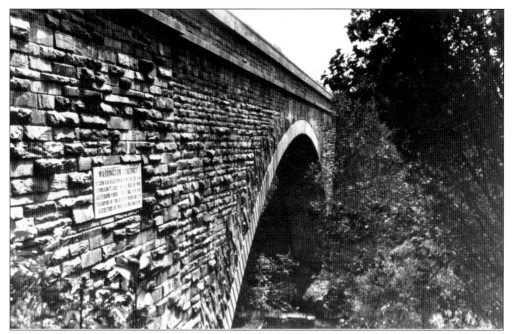

This photo shows a side view of the Washington Aqueduct. Note the plaque mounted on the side. This 12-mile aqueduct was a result of an initial idea by George Washington to bring the waters of Great Falls into the new federal city. Construction was finally completed, and it began carrying water to Georgetown in 1864. (Courtesy C&O Canal National Historical Park Headquarters, E.B. Thompson Collection.)

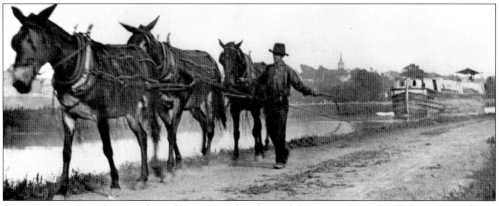

It is just another day on the job in the life of canal boatman Tom McKalvey. Here he is with his team of mules and barge at Georgetown. (Courtesy C&O Canal National Historical Park Headquarters.)

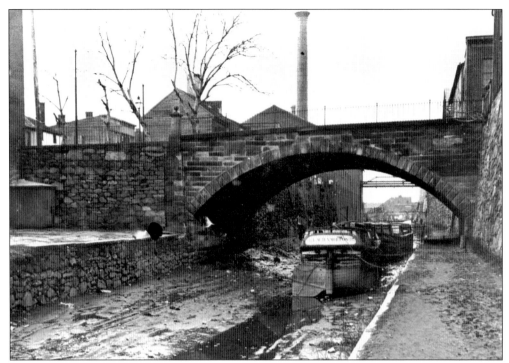

This *c.* 1880 photo taken in Georgetown shows a canal boat under the Wisconsin Avenue Bridge. The canal was drained for the winter as the stranded *E.M. Hamilton* shows. In early years, the canal boats were given individual names; later, the Canal Towage Company provided all the boats and they carried only a company boat number. (Courtesy C&O Canal National Historical Park Headquarters.)

On the corner of Wisconsin Avenue is a monument to the C&O Canal. Taken September 4, 1940, the photo shows the canal flowing under Wisconsin Avenue. (Courtesy C&O Canal National Historical Park Headquarters.)

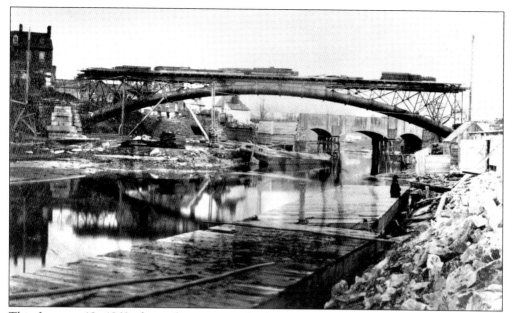

This January 18, 1860 photo shows a pipe bridge over the canal. This bridge now carries Pennsylvania Avenue and was part of the Washington Aqueduct that still brings water into the city from Great Falls. The M Street bridge is in the background. (Courtesy C&O Canal National Historical Park Headquarters.)

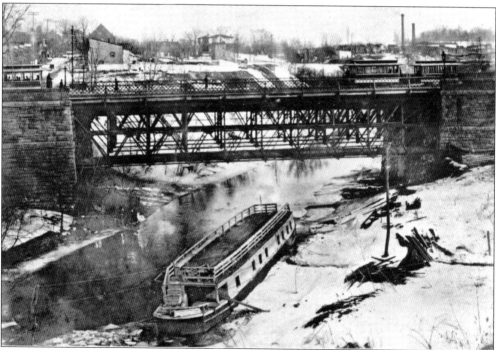

This vintage photo, c. 1890 to 1900, shows the M Street bridge. Note the packet boat in the canal, the snow-covered banks, and the old trolleys of the Washington and Georgetown Railroad crossing over the canal on the bridge. (Courtesy C&O Canal National Historical Park Headquarters.)

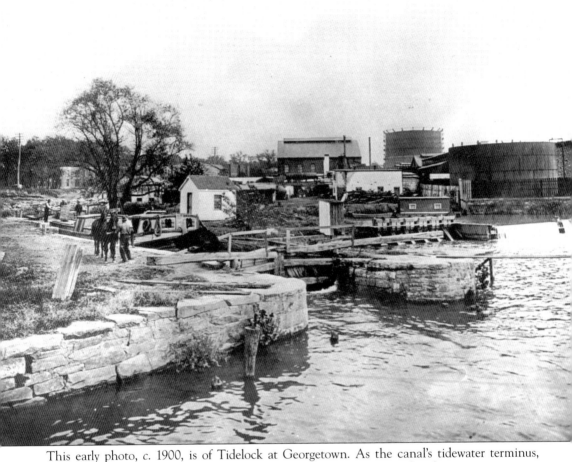

This early photo, c. 1900, is of Tidelock at Georgetown. As the canal's tidewater terminus, Georgetown was so busy during the height of the canal's usage that boatmen sometimes waited in lines five miles long for several days to get through. Georgetown was an extremely prosperous, independent town and had been a port for more than 150 years when the canal was completed. Prior to the American Revolution, the town was given its name in honor of King George. The canal and the traffic and commerce it brought gave Georgetown an edge over rival port Alexandria, Virginia. Some canal families did all their shopping for the year in Georgetown. Today the Watergate Complex, of Nixon-era fame, rises behind the scene of this photo. (Courtesy C&O Canal National Historical Park Headquarters.)

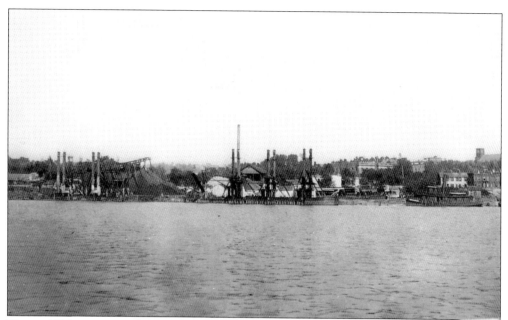

This *c.* 1890 panorama shows tidelock and the coal wharves at Georgetown. (Courtesy C&O Canal National Historical Park Headquarters.)

This photo shows tidelock in the 1940s, more than a decade after the canal ceased operations. Known as Milepost 0, this is the point where Rock Creek Basin and the Potomac River join and from where mileage distances along the canal are calculated. During the days of canal activity, sand, gravel, and coal wharves were located to the west of the lock. (Courtesy C&O Canal National Historical Park Headquarters.)

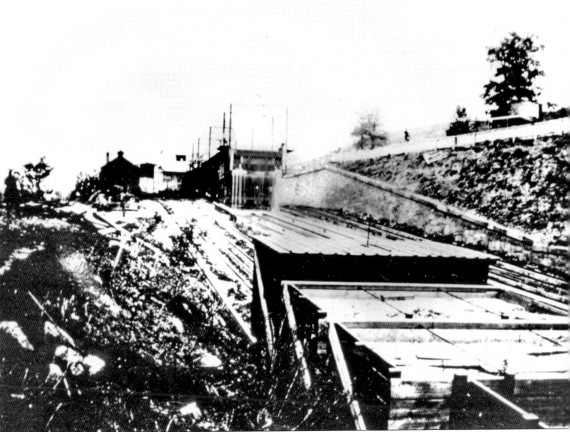

The Georgetown Inclined Plane was located near Fletcher's Boathouse. This 1870s photo shows the invention that was designed to lower canal boats 300 feet from the canal to the Potomac River and to help relieve the congestion of boats in Georgetown. Those boats that did not need to unload at Georgetown could be lowered into the river via the incline. Two massive sets of counterweights (200 tons each) traveled along the outside rail tracks of the incline while the canal boat floated on a water-filled caisson that traveled on the middle tracks. The Incline was heralded at the 1878 Paris Exposition as an engineering marvel of its time. (Courtesy C&O Canal National Historical Park Headquarters.)

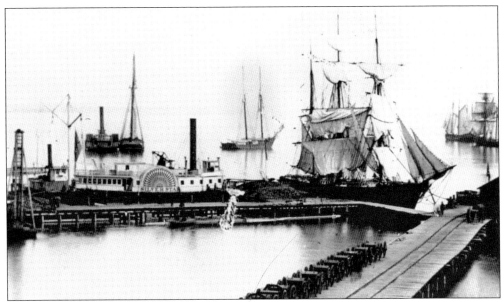

Canal boats were not the only ones found at the Georgetown wharves. This 1860s photo shows a paddlewheel steamship and a sailing ship in dock. Georgetown predates Washington, DC, and served as a main east coast port for domestic and European trade. As late as 1850, Georgetown still maintained its independent town charter. (Courtesy C&O Canal National Historical Park Headquarters.)

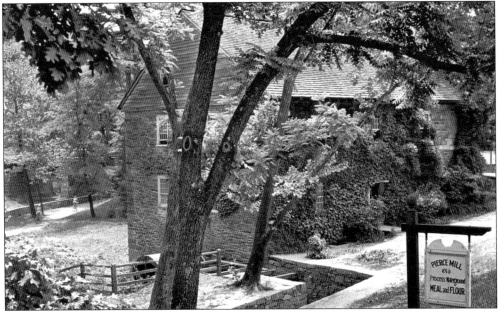

This photo shows Pierce Mill near the tidelock area. The sign out front proclaims that "Old Process Waterground Meal and Flour" are produced at the mill. The mill was built in the 1820s and closed in 1897. The federal government took over Rock Creek Park in 1892 and the mill was part of that acquisition. There are plans to make this site, listed on the National Register of Historic Places, functional again in the future. (Courtesy C&O Canal National Historical Park Headquarters.)

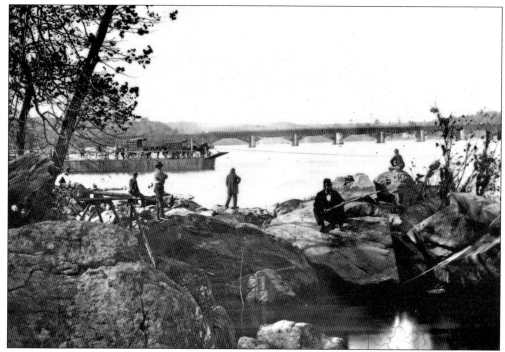

This 1865 Civil War–era photo shows the Aqueduct Bridge and Georgetown Ferry. Note the horse-drawn vehicles on the ferry and the armed soldiers on the rocks. (Courtesy C&O Canal National Historical Park Headquarters.)

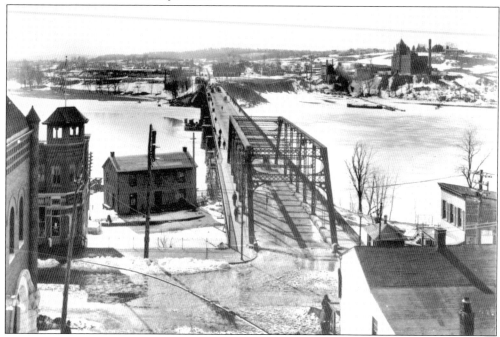

This is a view of the Alexandria Aqueduct after it was turned into a bridge. This bridge remained in operation in Georgetown until Key Bridge was built in 1933. Note the snow on the ground and the ice covering the river. (Courtesy C&O Canal National Historical Park Headquarters.)

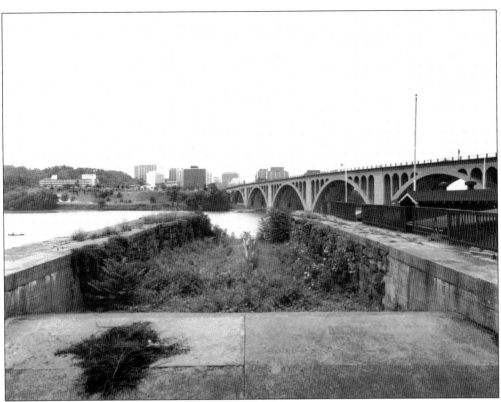

This photo shows the Alexandria Aqueduct abutment looking toward Roslyn, Virginia, with the Key Bridge on the right. Opened in 1843, the 1,100-foot aqueduct carried canal boats headed for Alexandria across the Potomac River. Upon reaching Alexandria, a series of lift locks lowered the boats into the Potomac. (Courtesy C&O Canal National Historical Park Headquarters.)

Taken in 1943, this photo is of a canal marker sign near Key Bridge in Washington, D.C. The sign stands in tribute to the national growth and progress that occurred during the early years of our country's independence. The Francis Scott Key bridge was named for the author of "The Star Spangled Banner," who lived in a house at the east end of the bridge for a time. Disruptions from the construction of the canal caused him to move from the location. (Courtesy C&O Canal National Historical Park Headquarters.)

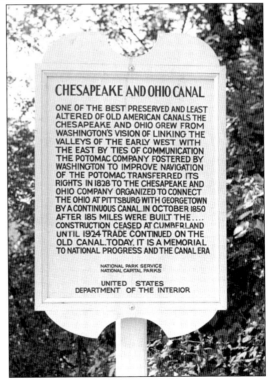

CHESAPEAKE AND OHIO CANAL

ONE OF THE BEST PRESERVED AND LEAST ALTERED OF OLD AMERICAN CANALS THE CHESAPEAKE AND OHIO GREW FROM WASHINGTON'S VISION OF LINKING THE VALLEYS OF THE EARLY WEST WITH THE EAST BY TIES OF COMMUNICATION THE POTOMAC COMPANY FOSTERED BY WASHINGTON TO IMPROVE NAVIGATION OF THE POTOMAC TRANSFERRED ITS RIGHTS IN 1828 TO THE CHESAPEAKE AND OHIO COMPANY ORGANIZED TO CONNECT THE OHIO AT PITTSBURG WITH GEORGETOWN BY A CONTINUOUS CANAL. IN OCTOBER 1850 AFTER 185 MILES WERE BUILT THE CONSTRUCTION CEASED AT CUMBERLAND UNTIL 1924 TRADE CONTINUED ON THE OLD CANAL. TODAY, IT IS A MEMORIAL TO NATIONAL PROGRESS AND THE CANAL ERA

NATIONAL PARK SERVICE
NATIONAL CAPITAL PARKS

UNITED STATES
DEPARTMENT OF THE INTERIOR

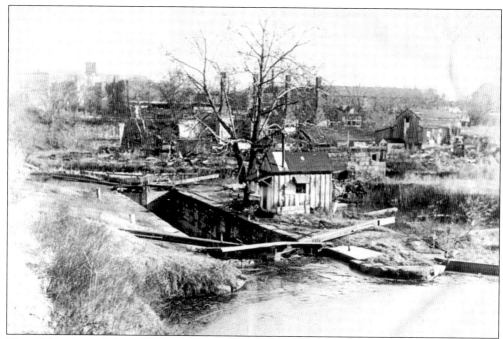

This 1900 photo of Georgetown shows Lock 1. Lime kilns and the city of Washington can be seen in the background. Boats entered Rock Creek below at the tidelock, but this spot at Lock 1 is the beginning of the canal. (Courtesy C&O Canal National Historical Park Headquarters.)

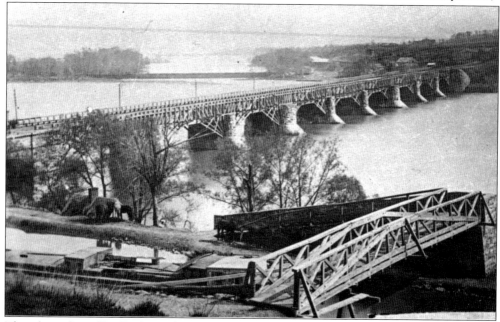

This photo shows Key Bridge and Lock 1 in Georgetown. Canal boats heading for Alexandria, Virginia, crossed the Potomac on the Alexandria Aqueduct. Four lift locks lowered the boats to the Potomac when they reached Alexandria. Built in 1843, the aqueduct survived and in 1886 was converted to a bridge until the Key Bridge was built in 1933. (Courtesy C&O Canal National Historical Park Headquarters.)

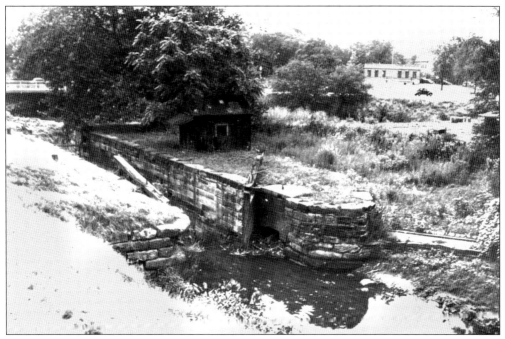

This is a photo of Lock 1 looking up at Pennsylvania Avenue. The neglected canal had fallen into disrepair at the time of this photo. Note the vintage cars passing over the bridge and along the road. (Courtesy C&O Canal National Historical Park Headquarters.)

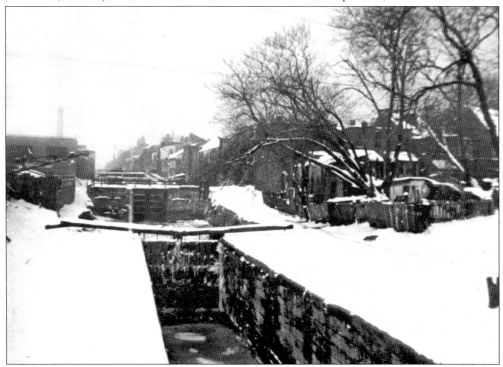

This winter view, c. 1935, shows Locks 2 and 3 in Georgetown. (Courtesy C&O Canal National Historical Park Headquarters.)

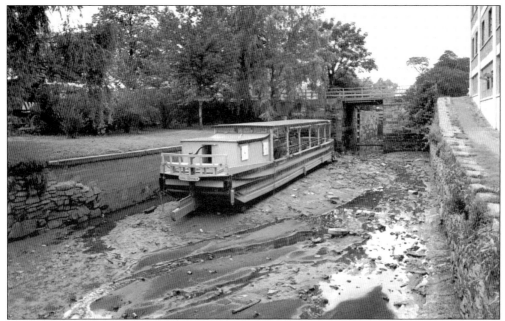

This 1962 photo shows the excursion barge *Canal Clipper II* in dry dock at Lock 2 in Georgetown. The canal is drained during the winter months and rides are resumed from mid-April to mid-October. (Courtesy C&O Canal National Historical Park Headquarters, photo by Abbie Rowe.)

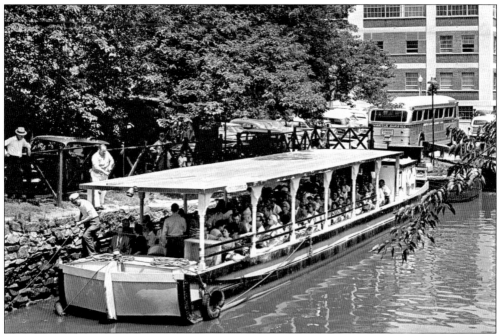

This is the new *Canal Clipper* excursion barge photographed on June 18, 1961. The boat is full of sightseers ready for a ride along the canal. Today, visitors can ride a canal barge from either Georgetown or Great Falls. Costumed interpreters provide insightful details about canal life. (Courtesy C&O Canal National Historical Park Headquarters, photo by Abbie Rowe.)

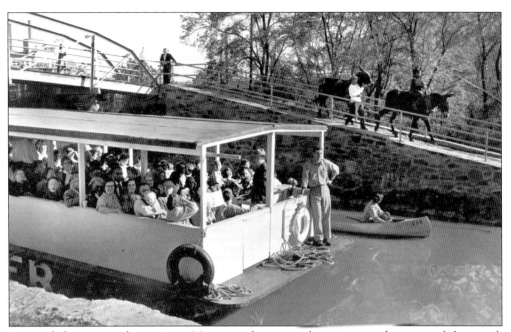

A crowded excursion boat takes visitors out for a trip along a restored section of the canal. Note the mule bridge over 34th Street. (Courtesy C&O Canal National Historical Park Headquarters, photo by Abbie Rowe.)

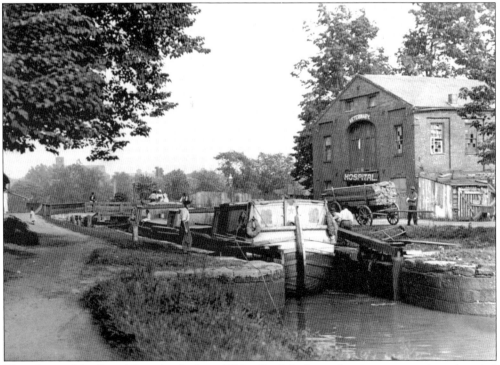

This photo of the Duval Foundry, built in 1856 at Lock 3, shows that it was a veterinary hospital at the time of the picture in 1900. Canal mules in need of care were treated here. (Courtesy C&O Canal National Historical Park Headquarters.)

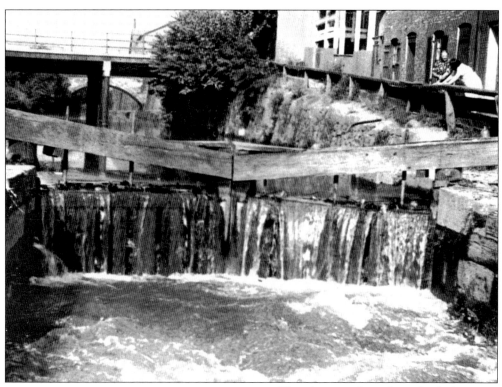

This close-up photo shows Lock 4 at Georgetown in the 1950s. Note the water churning as it pours through the lock gates. Some curious passersby lean over the railing above on the right to watch. (Courtesy C&O Canal National Historical Park Headquarters.)

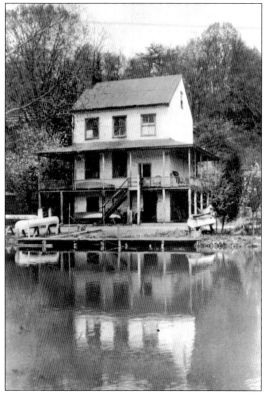

The Abner Cloud house is the oldest structure along the canal. Built in 1801, it held in its basement the grain and flour from the mill that Abner Cloud ran. Today, the structure has been restored. This photo shows the home as it appeared in 1939. (Courtesy C&O Canal National Historical Park Headquarters.)

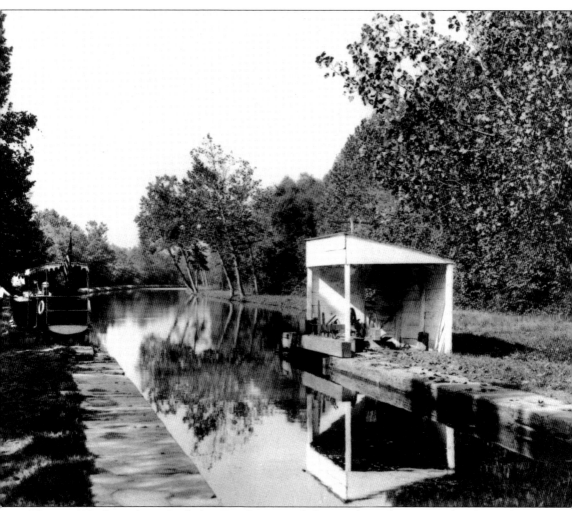

This c. 1918 photo shows Lock 5 at Brookmont and the winch mechanism used to lower the drop gate. The drop gate was a technological improvement over the swing gate found on the majority of C&O Canal locks. The drop gate was easier and quicker to operate, but in spite of this, few were installed along the canal. Much of the canal up to Lock 5 follows the bed of the Patowmack Company's Little Falls Skirting Canal. The first of the inlet locks that brings diverted water from Dam 1 into the canal is next to Lock 5. One half mile upriver, the Little Falls area of the Potomac marks the end of tidal influences on the canal. (Courtesy C&O Canal National Historical Park Headquarters.)

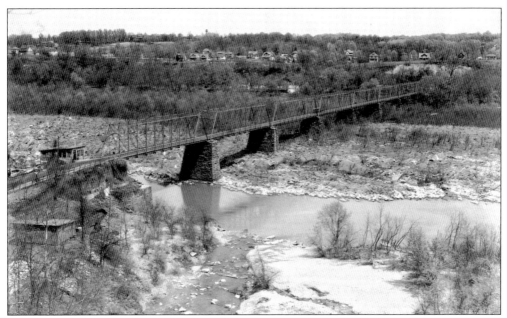

This is an older view of Chain Bridge just below Little Falls in Washington, D.C. The bridge takes its name from its composition in the early 1800s as a chain suspension bridge. A popular Civil War story tells how the first Union sentinel to be court-martialed for falling asleep at his post did so on this bridge. Lincoln later pardoned the man for his misdeed. (Courtesy C&O Canal National Historical Park Headquarters.)

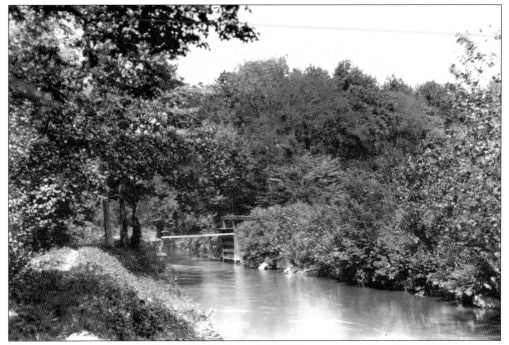

This is a quiet scene of the Little Falls feeder in 1945. This area is a relic of the old Patowmack Company's venture. The section from Little Falls to Seneca Creek was the first part of the canal to be completed. (Courtesy C&O Canal National Historical Park Headquarters.)

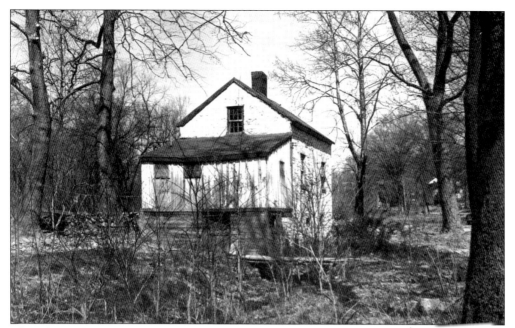

This photo shows Lockhouse 6 at Brookmont, Maryland. Lock 6 was also known as the Magazine Lock because the United States Powder Magazine was nearby, around a corner of the canal. (Courtesy C&O Canal National Historical Park Headquarters.)

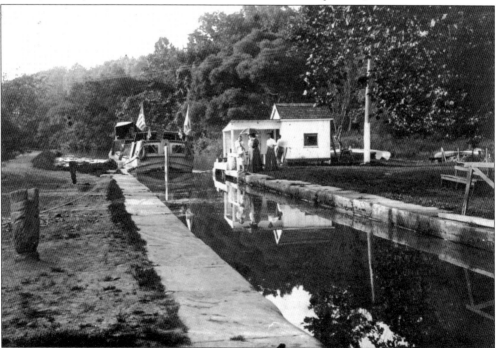

This Consolidated Coal Company photo shows boat #70 captained by Ralph Dick coming through Lock 7 at Glen Echo, c. 1908. Now the site of Glen Echo Park, it is administered by the National Park Service along with the nearby home of Clara Barton, founder of the American Red Cross. (Courtesy C&O Canal National Historical Park Headquarters.)

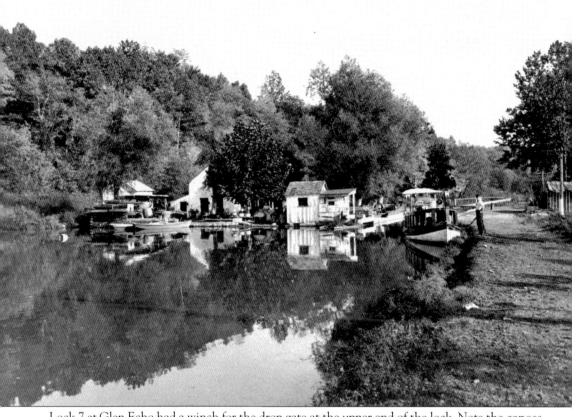

Lock 7 at Glen Echo had a winch for the drop gate at the upper end of the lock. Note the canoes and concessions in place. Begun in 1891 as the site of a National Chautauqua "to promote liberal and practical education, especially among the masses of the people; to teach the sciences, arts, languages, and literature; to prepare its patrons for their several pursuits and professions in life; and to fit them for the duties which devolve upon them as members of society," and later an amusement park, Glen Echo is now managed by the National Park Service. (Courtesy C&O Canal National Historical Park Headquarters.)

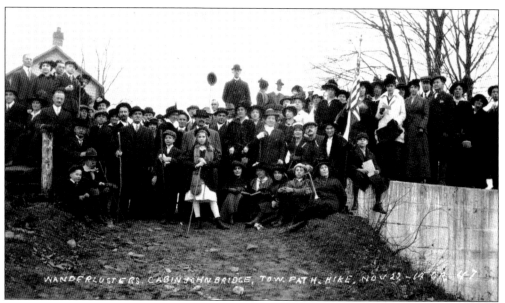

Recreational activities along the canal have long been a tradition. This November 22, 1914 photo shows the Wanderlusters at the Cabin John Bridge during a towpath hike. The group included youths and adults; they tramped along paths throughout the region. Note the flag bearer and what appears to be someone holding a horn instrument in this posed photo. The bridge was completed in 1864 and was, at the time, the largest single span in the western hemisphere. (Courtesy C&O Canal National Historical Park Headquarters, Elsie Gurney Collection.)

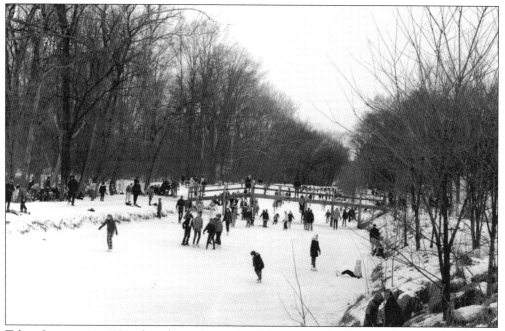

Taken January 11, 1970, this photo shows the Cabin John Creek area of the canal. Freezing temperatures created an icy surface for skaters to enjoy. (Courtesy C&O Canal National Historical Park Headquarters, photo by Jack Rottier.)

This October 13, 1941 photo shows the Seven Locks area of the canal. Encompassing Locks 8 through 14, the Seven Locks segment raises the canal 56 feet in just a 1.25-mile distance. Locks 9, 10, and 12 have drop-style gates instead of the usual swing gates. The intention was to help move boats through Seven Locks more quickly—lock-through times of an hour or more were not uncommon. (Courtesy C&O Canal National Historical Park Headquarters.)

This photo shows the lockhouse at Lock 8, the first of the Seven Locks, in 1958. The 1829 house looks as though it is occupied—note laundry hanging near the front screened porch. While Lock 8 was the standard swing gate type, other locks in the Seven Locks region were of the more advanced drop gate type. (Courtesy C&O Canal National Historical Park Headquarters.)

This is a close-up side view of Lockhouse 10 in the Seven Locks region. The photo dates from 1938, more than a dozen years after canal operations ceased in 1924. The stone house is the common form of lockhouse on the lower reaches of the canal. (Courtesy C&O Canal National Historical Park Headquarters.)

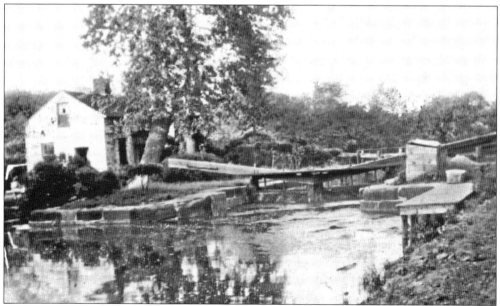

This photo of the stone Lockhouse 11 was taken in 1941, after the canal closed and the United States was on the brink of entering World War II. Unlike the years of World War I, this time the canal played no role in carrying on the commerce of the nation. (Courtesy C&O Canal National Historical Park Headquarters.)

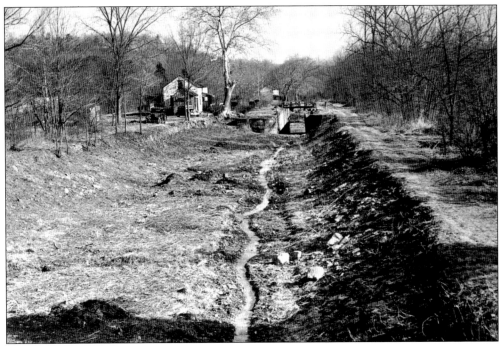

This is a view of Lock and Lockhouse 13, part of the Seven Locks region, during the winter of 1938–1939. It shows the disused, dried canal leading to the lock. The old car parked near the house is indicative of the home being occupied. This lockhouse was later destroyed when the Capitol Beltway (Interstate 495) was built. (Courtesy C&O Canal National Historical Park Headquarters.)

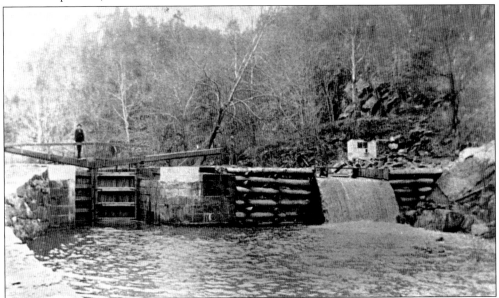

Lock 15 is the first of the group of locks known as Six Locks. Located at the head of Widewater, Locks 15 through 20 come in quick succession in the space of one mile. Note the log wall extending across the lock in the photo as well as the stone wall extending below the lock. (Courtesy C&O Canal National Historical Park Headquarters.)

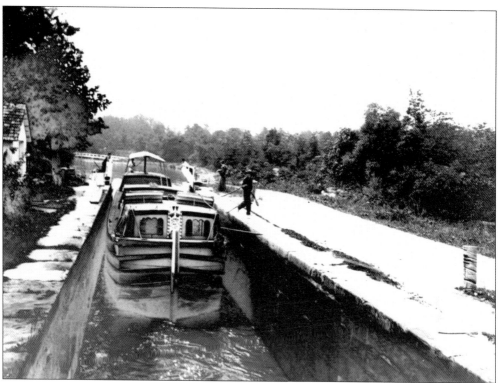

This great winter photo shows canal boats locking through Lock 15. The downstream view shows Widewater, a favored spot for anglers and canoeists. Canal boats often tried to get in "just one more" trip each year before the canal was drained for the winter. Boats made approximately 25 trips per season. (Courtesy C&O Canal National Historical Park Headquarters.)

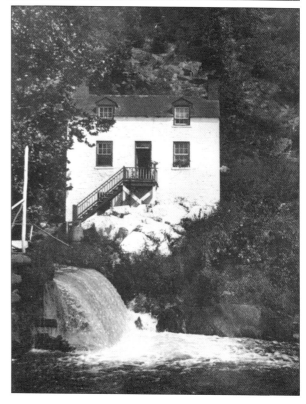

This image shows Lockhouse 16 and a canal bypass flume in 1900. The two-and-a-half story house was built c. 1837. Each of the locks in Six Locks had good bypass flumes, which were used to re-route water that backed up at locks. When a flume was not enough to handle the volume of water, a waste weir was constructed instead. (Courtesy C&O Canal National Historical Park Headquarters.)

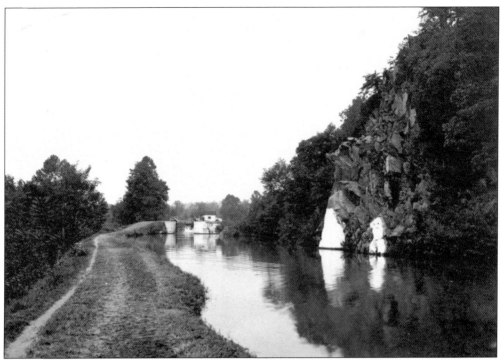

This 1920 photograph shows Lock 17 in the distance. Note the white-washed rocks along the cliffs above the canal. (Courtesy C&O Canal National Historical Park Headquarters.)

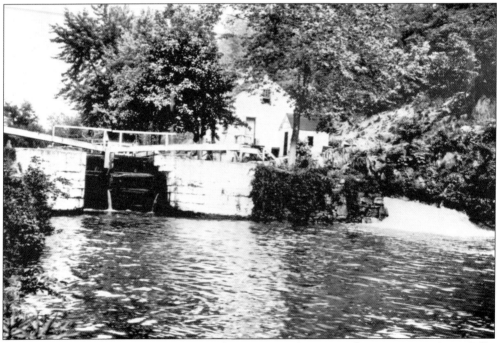

Taken around 1900, this photo shows Lock 18, part of the Six Locks region near Great Falls. The lock, lockhouse, and water flowing into the canal on the right can be seen in this image. (Courtesy C&O Canal National Historical Park Headquarters.)

Almost covered in overgrowth, the ruins of Lockhouse 18, which burned in the early 1930s, are visible in this photograph. (Courtesy C&O Canal National Historical Park Headquarters.)

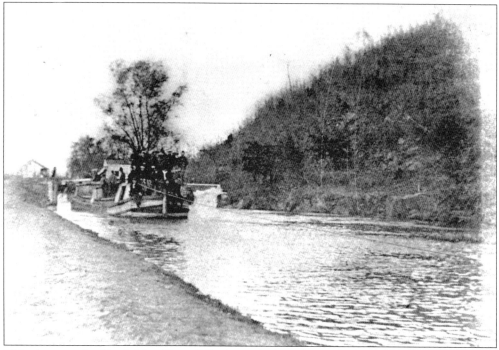

This photograph of Lock 19 at Great Falls shows the barn located at Lock 20 in the background. The rope from the canal barge to the mule on the towpath can be seen across the middle of the photo. (Courtesy C&O Canal National Historical Park Headquarters.)

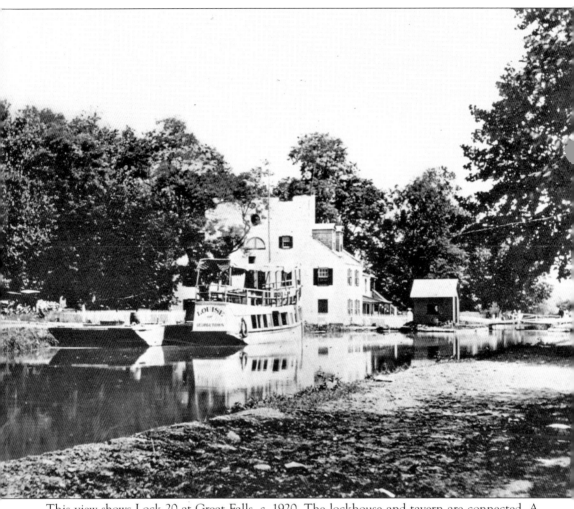

This view shows Lock 20 at Great Falls, c. 1920. The lockhouse and tavern are connected. A lock shanty stands on the lock wall; the shanty was where the lock tenders went to stay out of bad weather and at night when barges came through. The *Louise*, a passenger excursion boat, is moored alongside a canal company work scow. Note the buggies at the far left. Built in 1829, the lockkeeper's house was enlarged twice by 1831, when it became known as Crommelin House. It served as a popular hotel throughout the 19th century. Now more popularly known simply as Great Falls Tavern, it serves as the Great Falls Visitor Center for the C&O National Historical Park. (Courtesy C&O Canal National Historical Park Headquarters.)

The Great Falls area looks northeastward immediately above the Great Falls tavern in this c. 1900 photograph. The structure on the berm on the right bank of the canal is the Great Falls shop building where the canal maintenance forces made their headquarters. Enclosed by the picket fence is the old Washington Aqueduct Reservation. Notice the grass-covered berm embankment and the well-worn towpath. (Courtesy C&O Canal National Historical Park Headquarters.)

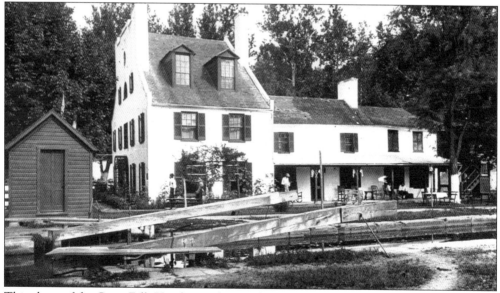

This photo of the Great Falls Hotel was taken in the 1880s or 1890s. Lock 20 is in the foreground of the photo with the stately inn behind it. Note that it was no distance at all between stepping off your boat in the canal to stepping into the inn's entrance. Today, the tavern serves as a C&O Canal Visitor's Center and the starting point for canal boat excursions. (Courtesy C&O Canal National Historical Park Headquarters.)

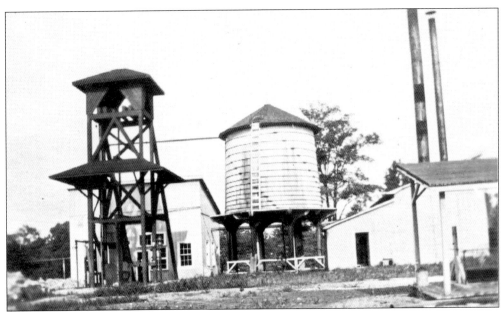

Maryland was once home to gold mining not far from the canal and the tavern at Great Falls. Following the Civil War, several gold mines were opened in the area. The most active time period for mining was from 1867 to 1916. This photo was taken between 1900 and 1918. (Courtesy C&O Canal National Historical Park Headquarters.)

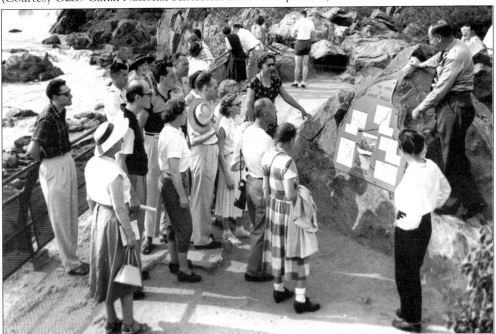

A crowd of visitors listens to a guide at Great Falls. The Potomac makes its sharpest drop at this point and the river surges with great force through narrow openings and over huge rocks. It is an awe-inspiring view of the forces of nature and was a popular site for Washingtonians to visit. Six locks were built to raise and lower boats the necessary 41 feet to traverse the Great Falls region. (Courtesy C&O Canal National Historical Park Headquarters, photo by Abbie Rowe.)

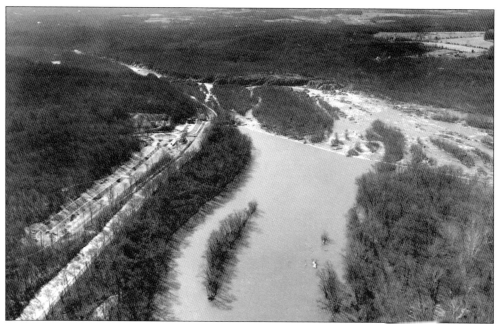

The relation of the river to the canal is illustrated in this aerial view that looks downstream over the falls at Great Falls, February 6, 1959. Note the canal on the left that, when in use, allowed the canal boats to safely bypass the dangerous currents of the un-navigable rocky falls. (Courtesy C&O Canal National Historical Park Headquarters, photo by Abbie Rowe.)

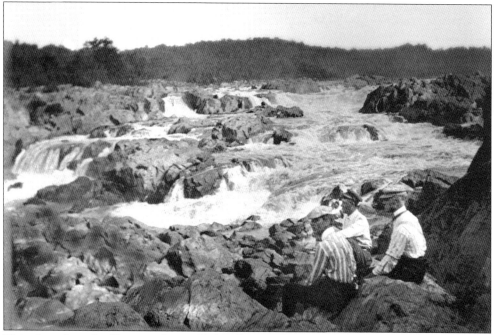

This photo from the Shawnee Canoe Club collection shows the "Great Falls of the Potomac" on June 25, 1904. These men are sitting on the rocks as close to the falls as they can get. How very "Turn of the 20th Century" the men look in their starched collars and striped shirts! (Courtesy C&O Canal National Historical Park Headquarters.)

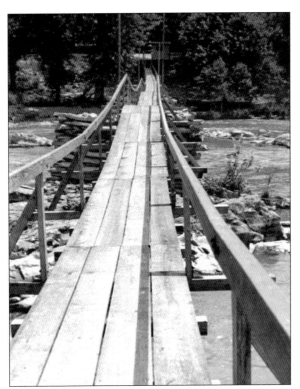

A suspension bridge at Great Falls, Maryland, is displayed in this 1937 photograph. Today, visitors can take a trip back to the 1870s on the *Canal Clipper* barge where interpreters dressed in period clothing recreate life on the canal. (Courtesy C&O Canal National Historical Park Headquarters.)

Visitors come back over the cable footbridge at Great Falls. Note the warnings about jumping or swinging. For 5¢ each, 25 people at a time were allowed on the bridge to witness nature's splendor. The views of the falls were popular with tourists and Washington residents for many years, but canal boat operators complained that the tourists interfered with "locking through" the region. (Courtesy C&O Canal National Historical Park Headquarters.)

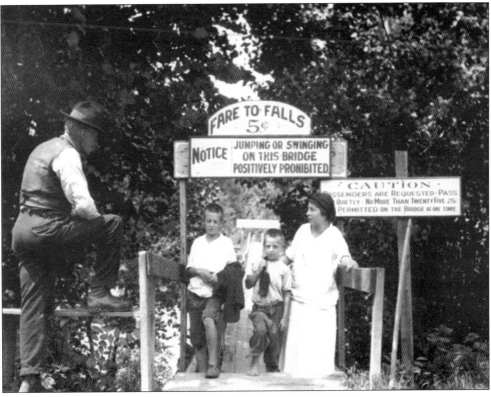

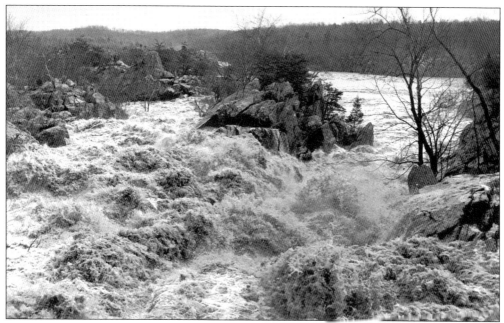

This photo, taken on March 3, 1951, shows the raging power of the river's high water at Great Falls. Just below Great Falls, the canal was constructed along a sheer drop to Mather Gorge below. Many a canaller held their breath while passing through this stretch! (Courtesy C&O Canal National Historical Park Headquarters, photo by Abbie Rowe.)

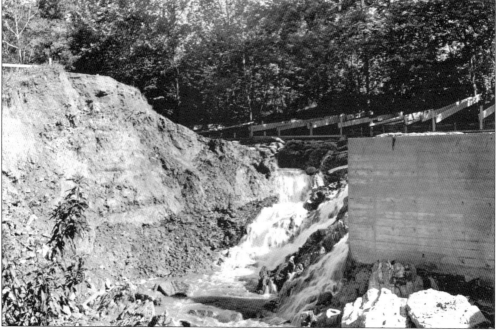

This July 1, 1941 photo shows a break in the towpath east of Widewater at Great Falls. The widewater area, actually a small lake 400 feet wide by a little less than a mile long, is the result of canal engineers using an old river channel during construction in this region. (Courtesy C&O Canal National Historical Park Headquarters.)

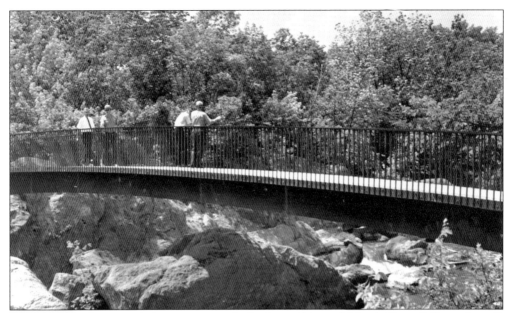

A National Parks ranger helps visitors on the bridge at Olmsted Island, Great Falls, on June 5, 1969. Olmsted Island offers a view over the magnificent falls. (Courtesy C&O Canal National Historical Park Headquarters, photo by Jack Rottier.)

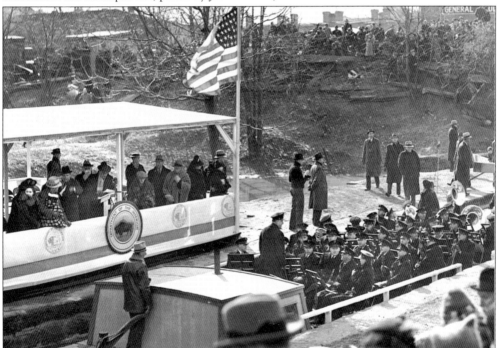

The C&O Canal Parkway was dedicated on February 22, 1939. Note the speaker's platform, the flag, and the large Department of the Interior seal. The United States Navy band is on the barge in the foreground. The lockkeepers on the speaker's stand are wrapped in blankets and the flag seems to be whipping in the wind, so it was probably a pretty chilly winter day. (Courtesy C&O Canal National Historical Park Headquarters.)

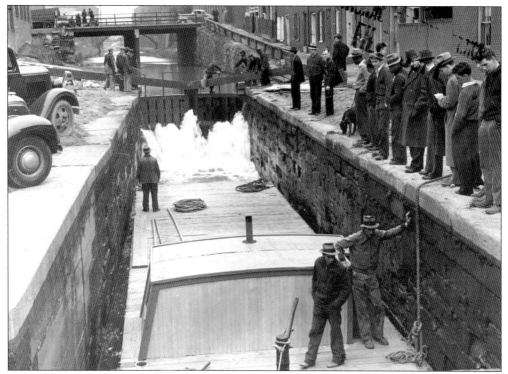

Another photo from the dedication of the C&O Canal as a recreational waterway in 1939 shows two boatmen on the canal barge in the foreground and the water entering the lock. In attendance at the dedication was the last surviving canal mule, Mutt. (Courtesy C&O Canal National Historical Park Headquarters.)

From a vantage point further back, this photograph depicts water flowing into the lock. (Courtesy C&O Canal National Historical Park Headquarters.)

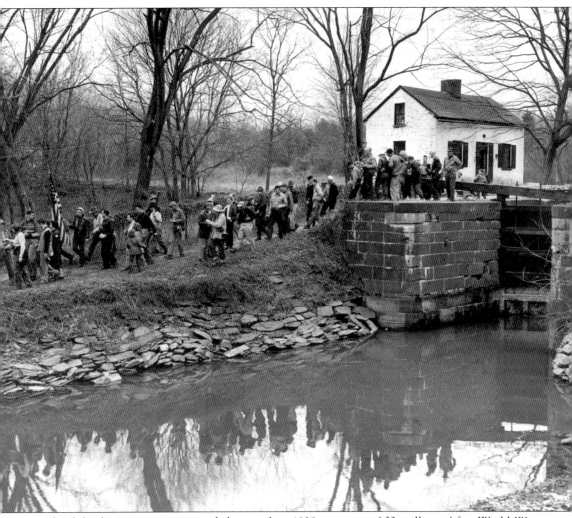

The federal government acquired the canal in 1938 at a cost of $2 million. After World War II, a proposal was put forth to turn the canal into an automobile parkway through the Potomac River Valley into western Maryland. Justice William O. Douglas was instrumental in preventing the canal from being paved over. In 1954, he challenged news editors from Washington, D.C. papers to walk the length of the canal with him to view its beauty and historical significance firsthand. As a result of the hike, the canal was preserved for future generations. This photo was taken during the 8-day hike on March 21, 1954. (Courtesy C&O Canal National Historical Park Headquarters, photo by Abbie Rowe.)

Two

SWAIN'S LOCK TO WEVERTON

A scenic stretch of the canal above Lock 21 is shown in this photograph. Known as Swain's Lock, Lock 21 takes its name from the family that has been associated with the canal since its construction. A member of the Swain family tended the lock when the canal closed in 1924 and the Swains continued to live in the house. (Courtesy C&O Canal National Historical Park Headquarters.)

The Pennyfield Inn at Lock 22, shown in this 1910s photograph, was located across the canal from the Pennyfield Lockhouse. President Grover Cleveland enjoyed staying and dining at the inn while bass fishing. (Courtesy C&O Canal National Historical Park Headquarters.)

This is a photograph of the lockhouse at Lock 23, also known as Violette's Lock. The lock received its name from the last locktender who lived there. (Courtesy C&O Canal National Historical Park Headquarters.)

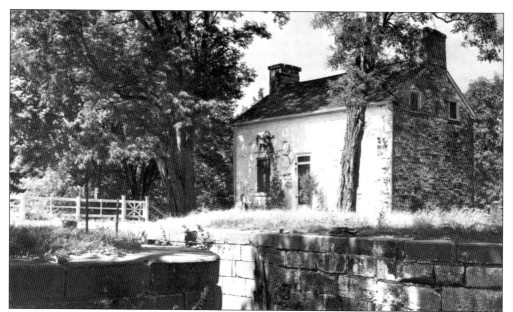

This 1936 photo shows Lockhouse 24, also known as Riley's Lock after Johnny Riley, the last lockkeeper at Seneca. The lock and aqueduct were constructed as one combined structure—the only occurrence of this on the canal. As boats left the lock, they traveled right into the Seneca Creek Aqueduct. (Courtesy C&O Canal National Historical Park Headquarters, photo by John Brostrup.)

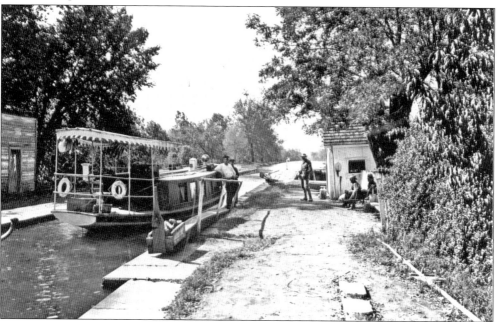

The canal was also home to water taxis as shown in this 1920 photo taken at Seneca Lock 24. The nearby Seneca Stonecutting Mill provided local sandstone for the construction of the Smithsonian Institution Castle and cut stone from other quarries for use in many other public buildings in Washington, D.C., such as the Capitol and the Washington Monument. (Courtesy C&O Canal National Historical Park Headquarters.)

This *Montgomery County Sentinel* article is from February 13, 1885, and makes reference to a decision to lower canal tolls for the coming boating season. The article notes that tolls were so high the previous year that boats sat idle and rotted because their owners could not afford to operate them. The cost of transporting coal from the mines in Cumberland to Georgetown is noted as $1.26 per ton. The rate for the same cargo to travel via rail at that time was $1.30 per ton. (Courtesy Western Maryland Room Washington County Free Library.)

This 1950s photo of Seneca Creek Aqueduct shows boaters enjoying the water while others watch from shore. The lift lock, aqueduct, and lockhouse were all built of Seneca red sandstone quarried nearby. The canal required 11 aqueducts between Seneca Creek and Cumberland. The aqueducts were costly to construct and required the skills of top stonemasons and quarrymen. Seneca Creek Aqueduct opened in 1833. (Courtesy C&O Canal National Historical Park Headquarters.)

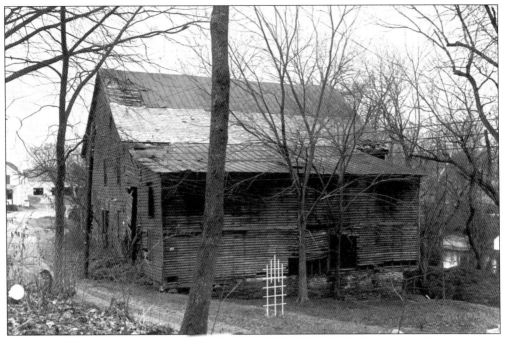

The Tschiffley Mill ruins rest on the banks of Seneca Creek. Flour from the mill made its way to Washington via the canal. In operation until 1931, the mill burned around 1956. (Courtesy C&O Canal National Historical Park Headquarters, photo by Abbie Rowe.)

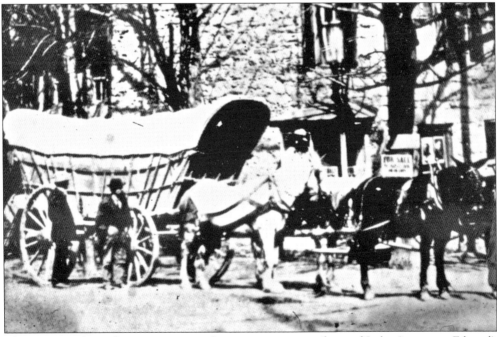

This vintage photo shows a man in a Conestoga wagon in front of Jarboe's store at Edward's Ferry, Lock 25. Lock 25 was the first of the locks along the canal to be extended in length to allow two boats to "lock through" at the same time. (Courtesy C&O Canal National Historical Park Headquarters.)

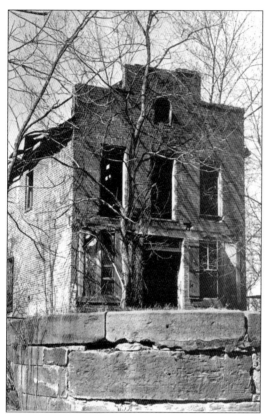

The ruins of Jarboe's store at Edward's Ferry are pictured in 1963. In its day, the store supplied not only the boating trade, but also the local community. Edward's Ferry was in operation here from 1791 until 1836. The store, which closed in 1906, was operated by two former locktenders, John Walters and Charlie Poole. It is no coincidence that the town of Poolesville, home to many other Poole family members, is not far away. (Courtesy C&O Canal National Historical Park Headquarters.)

This 1900 photo shows White's Ferry above Milepost 35. Several Indian villages were located in the vicinity, and troops used the ferry crossing here during the Civil War. The ferry crossing originally cost 6 $\frac{1}{4}$¢ each way per man, mule, or horse; cattle crossed for 3¢ per head; and a carriage cost 6$\frac{1}{4}$¢ per wheel. Today's car ferry is the *General Jubal A. Early*, named for the Confederate Civil War general and costs $5 for a round trip journey. (Courtesy C&O Canal National Historical Park Headquarters.)

This is another 1900 view of White's Ferry from the opposite direction. The ferry is the last operating ferry on the Potomac, running for over 150 years. Originally known as Conrad's Ferry in 1828 after owner and operator Earnest Conrad, it was purchased after the Civil War by Elijiah Veirs White, a prosperous attorney and sheriff from Loudoun County, Virginia. The ferry provides a link with Leesburg, Virginia, as well as Virginia Civil War sites such as Balls Bluff National Cemetery. (Courtesy C&O Canal National Historical Park Headquarters.)

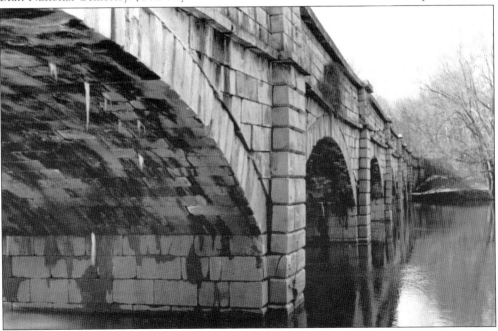

The Monocacy Aqueduct, the longest of the aqueducts at 560 feet, is photographed here. The seven-arch structure constructed of pink quartzite was once the jewel of the canal. The quartzite was quarried at nearby Sugarloaf Mountain, so named for its likeness to early settlers of a loaf of sugar. The Monocacy River was the site of a key Civil War battle known as the "Battle that Saved Washington." (Courtesy C&O Canal National Historical Park Headquarters, photo by Jack Routier.)

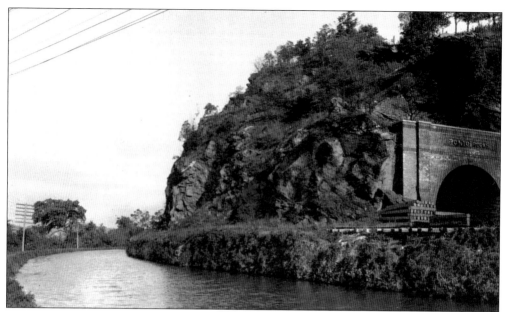

This 1920 Consolidated Coal Company photo shows the Point of Rocks, Maryland railroad tunnel running parallel to the canal. The right of way for this area was in dispute for years and the litigation held up construction of the canal. Finally, the right of way was awarded to the canal and the railroad was forced to tunnel through. (Courtesy C&O Canal National Historical Park Headquarters.)

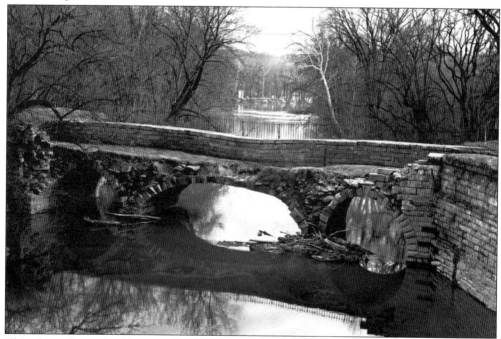

This photo shows the Catoctin Creek Aqueduct prior to its collapse. Due to a design flaw, the structure was known as the "Swaybacked" or "Crooked" Aqueduct. Note the significant dip in the center of the aqueduct, a clue to the imminent collapse of the center and upstream arches after a flood in 1973. (Courtesy C&O Canal National Historical Park Headquarters.)

Taken at Lander c. 1959, this is a photo of Mr. and Mrs. "Bugs" Cross and their daughter Mrs. Harry Browning. Mr. Cross was a former lockkeeper at the Lander Lock #29 and continued to live there until 1962. (Courtesy C&O Canal National Historical Park Headquarters.)

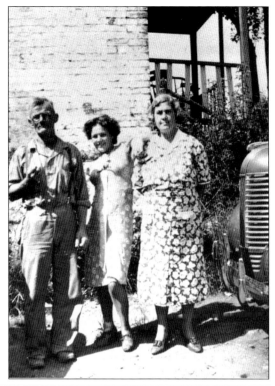

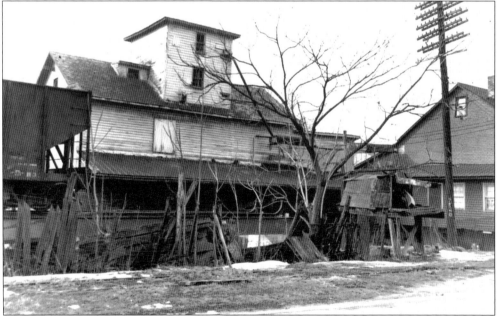

Founded in 1787, Brunswick, Maryland, has a reputation as a railroad town, but also has ties to the C&O Canal. Located at Milepost 55 along the canal, ferry service was the original mode of crossing the Potomac prior to the current bridge service. This 1964 photo shows a dilapidated mill from the canal days. Note the rail tracks in front of the mill and the hopper car to the left. (Courtesy United States Department of the Interior, National Park Service.)

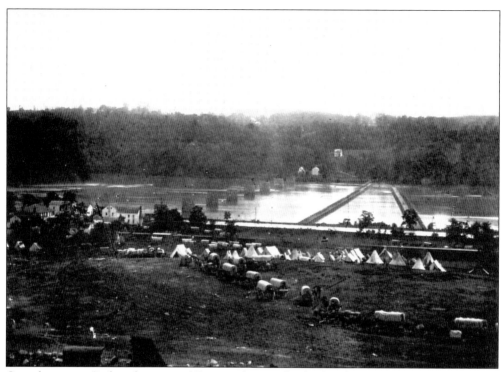

Once known as Berlin, the town of Brunswick, Maryland, played a role during the Civil War. In fact, some of the bridges that crossed the river were destroyed during the war. This July 1863 photo shows a segment of the Army of the Potomac crossing the river. Note the covered wagons with the tent encampment behind it. Buildings of the town of Berlin are to the left. (Courtesy C&O Canal National Historical Park Headquarters.)

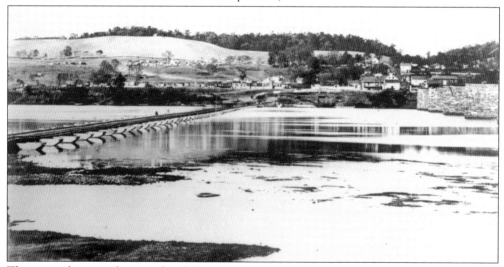

This is a close-up photograph of the pontoon bridge across the Potomac River at Berlin (Brunswick), Maryland, in October 1862. A pontoon bridge was not built on pilings based in the riverbed, but rather on pontoons that floated on the surface of the water. The Civil War was in progress and troops used this bridge to cross the river. (Courtesy C&O Canal National Historical Park Headquarters.)

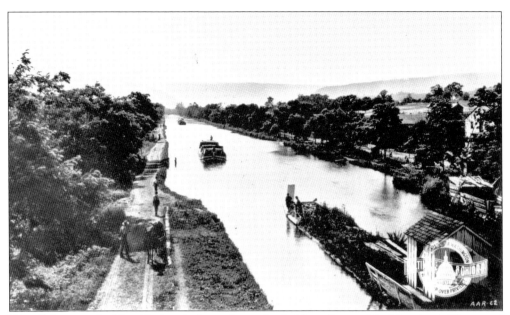

This Baltimore & Ohio Railroad photo shows Lock 30 at Brunswick, Maryland. The canal paralleled the right of way of the B&O Railroad for miles between Washington, D.C., and Martinsburg, West Virginia. In this photo, two boats are approaching the lock from downstream. The mules that pulled the towropes of the boat are moving along the towpath on the left. (Courtesy C&O Canal National Historical Park Headquarters.)

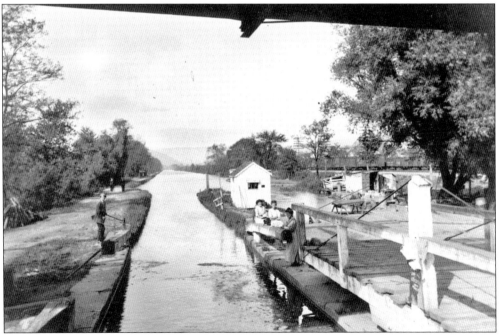

Taken in 1920 from the bridge over the canal, this photo of Lock 30 in Brunswick, Maryland, shows the rail yards to the right. Note the people in the middle near the gate house and to the left. This photo is one of a series taken along the canal by the Consolidated Coal Company. (Courtesy C&O Canal National Historical Park Headquarters.)

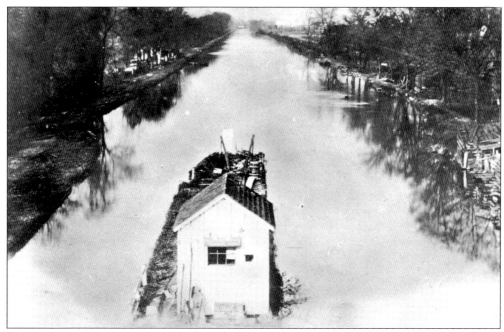

Another view of Lock 30 at Brunswick looks downstream from the lockkeeper's wait house in the middle of the canal. The C&O Canal National Historical Park opened its newest visitor's center in downtown Brunswick in 1999. (Courtesy C&O Canal National Historical Park Headquarters.)

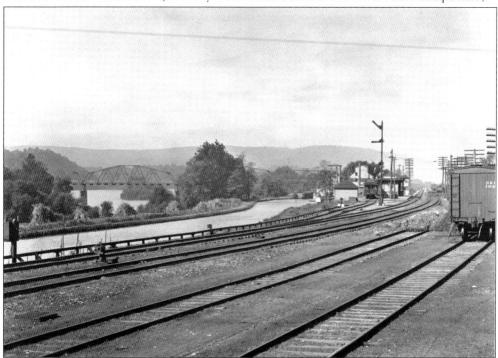

This Brunswick photo is an excellent view of the Potomac to the far left, the canal running down the middle, and the rail tracks to the right. (Courtesy C&O Canal National Historical Park Headquarters.)

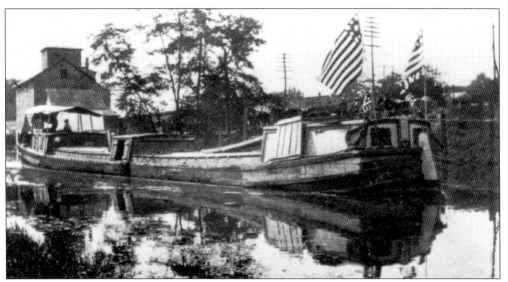

A canal boat with patriotic flags (no 50 stars yet on these old Stars and Stripes!) is near the mill in Brunswick, Maryland, around 1909 or 1910. This was the C&O Canal boat standard design. Boats were generally uniform in size—90 to 95 feet long and 14.5 feet wide. When fully loaded, a boat would draw about 4.5 feet. (Courtesy C&O Canal National Historical Park Headquarters.)

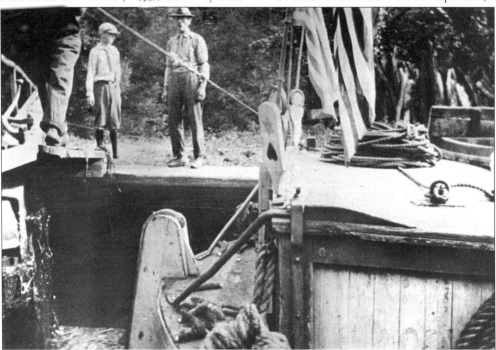

A boat "locks through" Lock 31 at Milepost 58 on the way downstream at Weverton, Maryland, in this 1923 photo. Taken from the opposite side of the lock, the vantage point shows the front of the boat and the water leaking from the lock gates on the left of the photo. Less than a mile from this point the 2,050 mile-long Appalachian Trail joins the towpath for a short distance to Sandy Hook Bridge on its route from Maine to Georgia. (Courtesy C&O Canal National Historical Park Headquarters, photo by Abbie Rowe.)

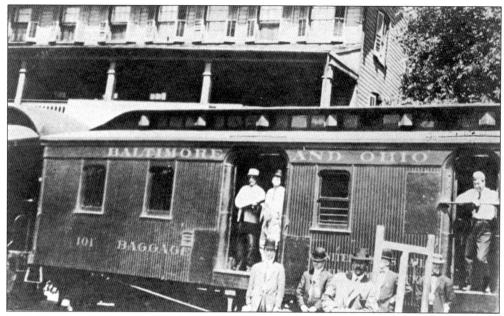

This 1900 photo was taken in front of the hotel and rail station in Weverton, Maryland. Having previously worked on the construction of the National Road and the Baltimore & Ohio Railroad (B&O), Caspar Wever hoped to develop a manufacturing center at Weverton that would rival that of Lowell, Massachusetts. His plan was based on the water power the falls below Harpers Ferry, West Virginia, would generate. Unfortunately, Wever died before he could see his dream through. (Courtesy C&O Canal National Historical Park Headquarters.)

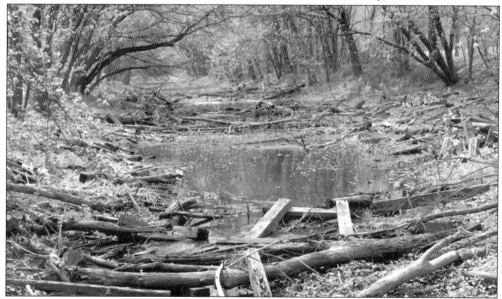

This April 23, 1988 photo was taken from Weverton, Maryland, looking upstream. It is hard to compare this wood debris–strewn area with the active, watered canal that flowed through here just 60 years earlier. It is areas like this that demonstrate the restoration and preservation task that the C&O National Historical Park Service faces in their efforts to preserve this important part of United States history. (Courtesy C&O Canal National Historical Park Headquarters.)

Three

HARPERS FERRY TO
LITTLE POOL

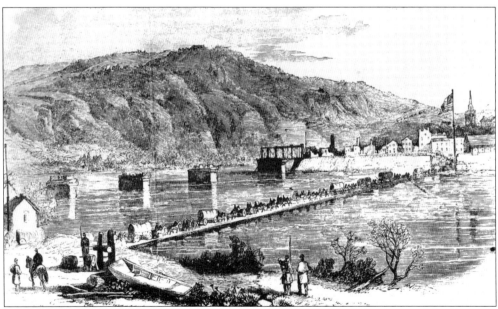

This February 26, 1862 sketch shows General Banks's division of the Army of the Potomac crossing the river at Harpers Ferry, West Virginia. Because the canal paralleled the Potomac River, which was the boundary between North and South during the Civil War, the canal was the site of much war action. Early during the war, control of the industrial center of Harpers Ferry passed back and forth between the North and South. (Courtesy C&O Canal National Historical Park Headquarters.)

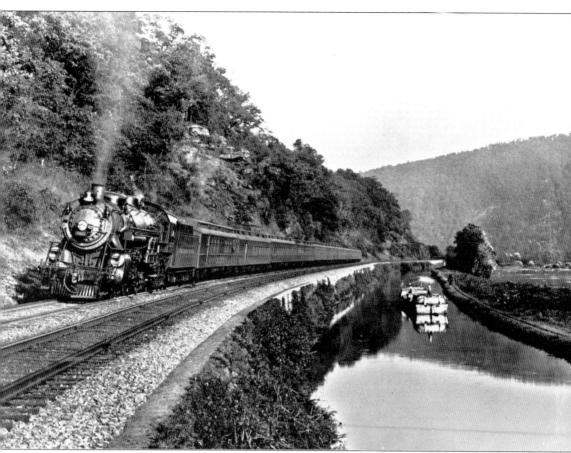

This scenic view depicts the competition of the railroad against the canal. The train steams alongside the C&O Canal as a canal barge progresses at a much slower rate. Some stories report that passing trains would sometimes intentionally blow their horns to frighten the mules along the towpath. The coming of the railroad and its promise of quicker, easier delivery of goods spelled the beginning of the end for the canal trade. Taken near Sandy Hook in 1923 just a year prior to the close of canal operations in 1924, this photo shows Canal Towage #49 bound for Washington, D.C., with 120 tons of coal. The train was Baltimore & Ohio's *Capitol Limited* on its way west to Cumberland. The boat's captain was George Bowers and the mule driver was Lloyd Lemen. Standing on deck is Heaver Eversole. All three men were from Williamsport, Maryland. (Courtesy C&O Canal National Historical Park Headquarters.)

This is a view of the rail tracks with the canal behind the trees as both pass through Sandy Hook below Harpers Ferry. (Courtesy C&O Canal National Historical Park Headquarters.)

No longer a watered area of the canal, this photo shows the towpath above the Shenandoah River Lock. The initial plan was for the towpath mules to cross the railroad bridge at this point and tow the barges up the Shenandoah River skirting canals. Built in 1833, this lock was the first river lock built; however, when the railroad refused to allow passage on the bridge, it was soon abandoned in favor of Lock 35 further upstream. (Courtesy C&O Canal National Historical Park Headquarters.)

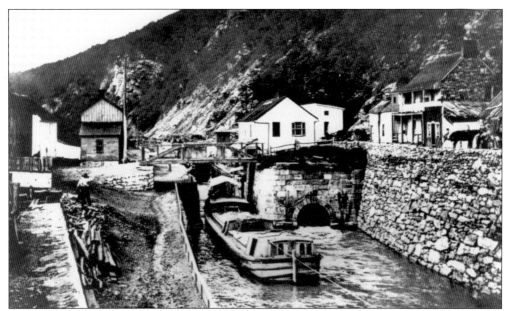

Located at the confluence of the Shenandoah and Potomac Rivers, Harpers Ferry was an important site along the canal. This *c.* 1900 photo shows Lock 33 at Harpers Ferry. The lockhouse, Spencer's store, and a canal culvert are to the right. A culvert was used to route creeks under the canal; if the creek was too large or deep, an aqueduct became necessary instead. (Courtesy C&O Canal National Historical Park Headquarters.)

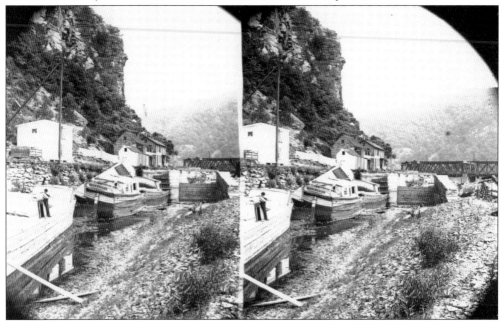

Stereoscopes were a popular pastime in the late 1800s and early 1900s; all kinds of photos were available. When held up to the light for viewing through a stereoscope, two images, each taken from a slightly different angle, merged into one "stereo" view. This image shows Lock 33 at Harpers Ferry, West Virginia, with the canal boat *Theodore* wrecked just above the lock. (Courtesy C&O Canal National Historical Park Headquarters.)

Taken near Lock 33 at Harpers Ferry, this 1920 photo shows a multitude of transportation methods. It shows the canal and towpath, the B&O Railroad, and the highway bridges. This is another in the series of Consolidated Coal Company photos. (Courtesy C&O Canal National Historical Park Headquarters.)

The 1889 rainstorm that wrecked havoc throughout the area also brought major flooding to the C&O Canal. This photo shows Lock 33 at Harpers Ferry with the wreckage of two canal boats tossed there by the high waters. The flood of 1924 was the final straw—the damage was too extensive and put the canal out of business for good. (Courtesy C&O Canal National Historical Park Headquarters.)

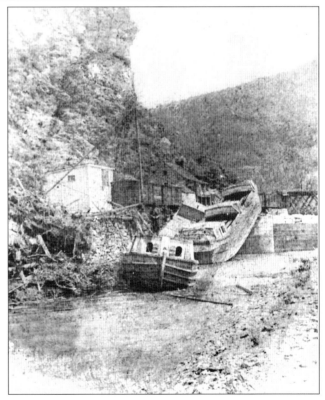

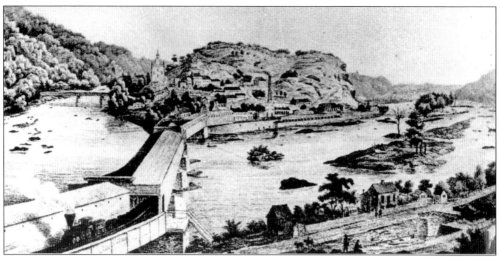

This pre–Civil War sketch from *Harper's Weekly* shows Lock 33 at Harpers Ferry, West Virginia. The lock is in the lower right of this scene and the town of Harpers Ferry rises on the hill across the river. A steam engine chugs its way over the tracks on the rail bridge in the foreground. (Courtesy C&O Canal National Historical Park Headquarters.)

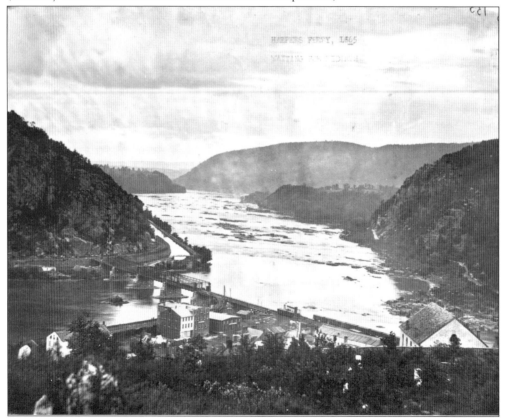

This 1865 photo of Harpers Ferry was taken from Camp Hill and shows the town waiting to recover from the Civil War. Note the small troop tent encampment near the tall building in the lower left section of the picture. (Courtesy C&O Canal National Historical Park Headquarters.)

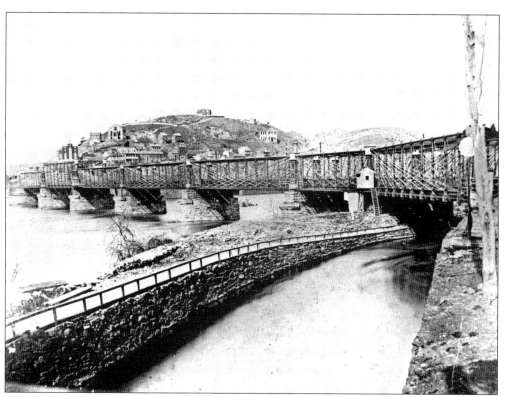

This truss bridge, built over the stone-walled canal after the Civil War, crosses the river at Harpers Ferry. (Courtesy C&O Canal National Historical Park Headquarters.)

Bikers ride along the towpath in 1965 at Lock 33 near Harpers Ferry, West Virginia. The old Salty Dog Tavern (so named sometime after the canal ceased operation) building is in the background. In operation for close to 100 years and known as a rowdy tavern along the canal, the notorious saloon operated as a moonshine supplier during Prohibition and remained in business into the 1940s. (Courtesy C&O Canal National Historical Park Headquarters, John Kaufman collection.)

Daily National Intelligencer.

RESUMPTION of DAILY LINE FOR HARPER'S FERRY.

THE Canal Packet Boats Belle and Fashion will resume their trips for the ensuing season between Harper's Ferry and Georgetown, commencing Monday, July 19.

Leaving Georgetown daily at 5½ P. M., arriving at Harper's Ferry next morning at 9 o'clock, in time for the cars for Winchester and Cumberland.

Returning, leave Harper's Ferry at 2 P. M., arriving at Georgetown next morning at 6 o'clock.

Omnibuses will be in readiness on the arrival of the packets at Georgetown to convey passengers to Washington.

Fare $2, including board. july 17—tf

This October 2, 1852 article notes details of canal passenger boat runs between Harpers Ferry and Georgetown. The article notes the boats will arrive in Harpers Ferry in time to make connections with trains for Winchester, Virginia, and Cumberland, Maryland. Note the $2 fare that also included overnight accommodation on the boat. (Courtesy C&O Canal National Historical Park Headquarters.)

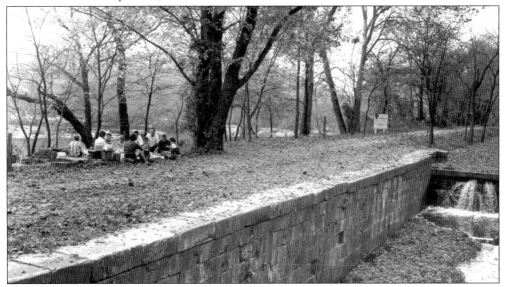

This pre-restoration photo of Goodheart's Lock 34 near Harpers Ferry shows picnickers to the left and the water leaking through the lock.

This serene 1959 scene also shows Lock 34. Goodheart's Lock was restored and re-watered by the National Park Service. (Courtesy C&O Canal National Historical Park Headquarters.)

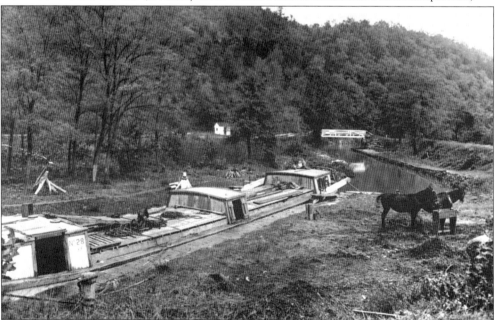

This 1920 Consolidated Coal Company photo was taken at Lock 35, an inlet lock at Dam 3. The inlet locks at each dam served to keep the canal watered. The photo shows Consolidated Coal Company barge #28 in the canal with the mules at the hitching post. Note the bridge crossing the canal in the background. Locks 35 and 36 are within one tenth of a mile from each other. (Courtesy C&O Canal National Historical Park Headquarters.)

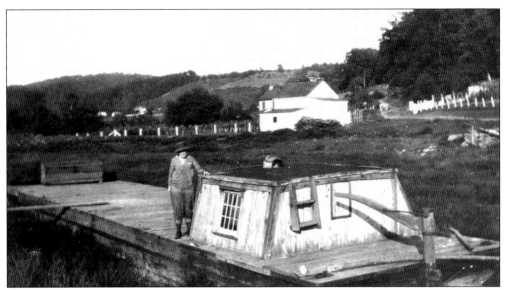

This image shows a C&O Canal repair scow at the Mountain Lock, number 37, in 1920. (Courtesy C&O Canal National Historical Park Headquarters.)

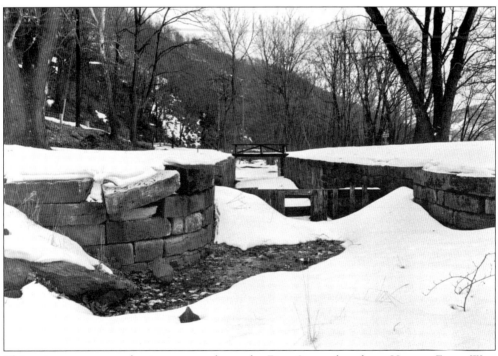

This quiet, snow-covered, winter scene shows the Dam 3 complex above Harpers Ferry, West Virginia. The dam was originally constructed in 1799 to provide power for the Harpers Ferry Armory. (Courtesy C&O Canal National Historical Park Headquarters.)

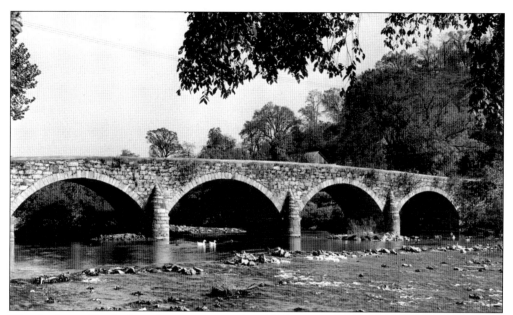

The Antietam Creek Aqueduct, constructed in 1834, is complete with paddling ducks in this view. Irish workers died in great numbers from a tragic outbreak of cholera during construction of the aqueduct, which would carry the canal over Antietam Creek near Antietam Furnace. This downstream photo was taken October 31, 1941. (Courtesy C&O Canal National Historical Park Headquarters.)

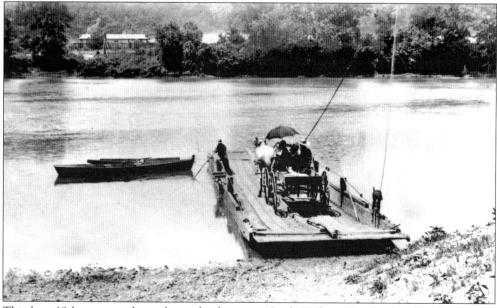

This late–19th century photo shows the ferry near Lock 38 from Maryland to Shepherdstown, West Virginia. The oldest town in West Virginia, Shepherdstown was named after its founder Thomas Shepherd. Located at Milepost 73, Ferry Hill plantation sits high above the lock overlooking the river. Until recently, the C&O Canal Historical Park Headquarters were located in the plantation, which took its name from the ferry. The park headquarters are now located in Hagerstown, Maryland. (Courtesy C&O Canal National Historical Park Headquarters.)

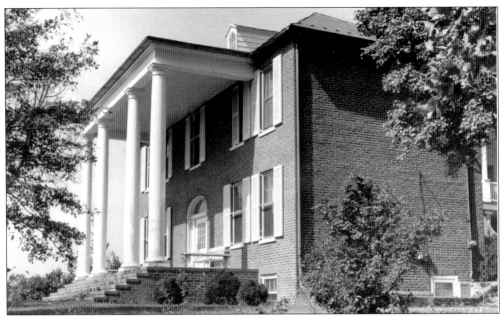

This is a photo of Ferry Hill, the former headquarters of the C&O Canal National Historical Park. Ferry Hill Plantation is located on the Potomac River, just a few miles below Sharpsburg. It is best known as the home of Henry Kyd Douglas, the youngest member of Stonewall Jackson's staff. In the years before the Civil War the home was occupied by John Blackford; he ran one of the largest slave operations in Washington County. (Courtesy C&O Canal National Historical Park Headquarters.)

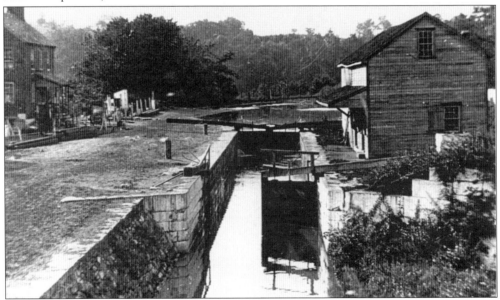

This is the Shepherdstown, West Virginia Lock and Lockhouse 38, c. 1900. The upstream view shows a feed store on the berm side. Boats from Shepherdstown entered the canal at the river lock here. Shepherdstown is home to James Rumsey, who built a working steamboat ten years before Robert Fulton, but it was Fulton who had the commercial success story. (Courtesy C&O Canal National Historical Park Headquarters.)

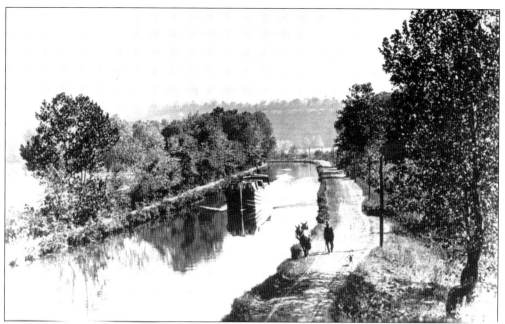

This pastoral scene shows a canal boat being towed in the Shepherdstown, West Virginia area near Lock 38, c.1890 to 1900. (Courtesy C&O Canal National Historical Park Headquarters, Herman Miller Collection.)

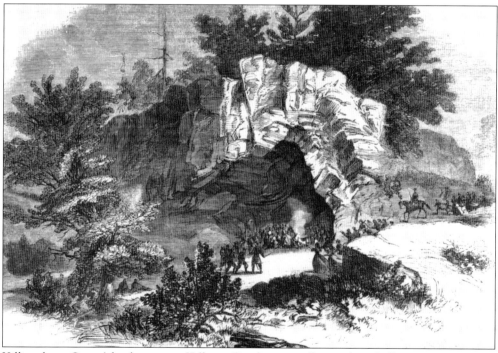

Killiansburg Cave (also known as Killings Cave) is actually a rather shallow opening with a large rocky overhang. Both before and during the battle at Antietam on the "bloodiest day" of the Civil War, citizens from nearby Sharpsburg, Maryland, sought refuge here. (Courtesy Western Maryland Room Washington County Free Library.)

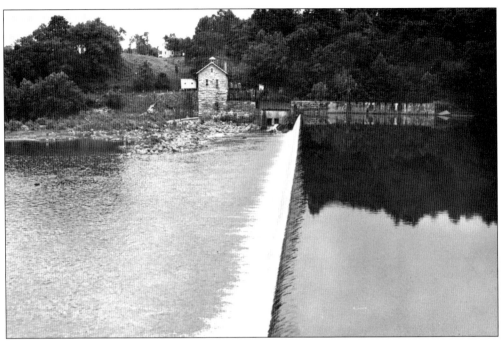

Now an excellent fishing area, this photo shows Dam 4 in Washington County, Maryland. The present dam was constructed in 1906 after previous structures suffered from flood damage. (Courtesy C&O Canal National Historical Park Headquarters.)

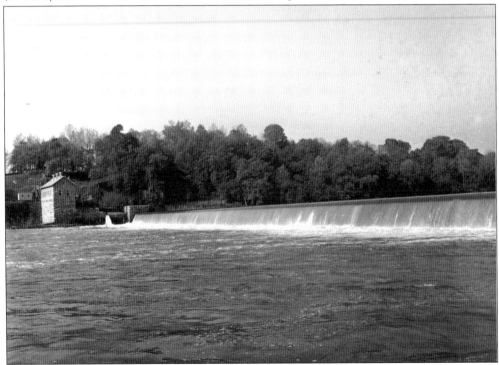

This is a view of the wide expanse of Dam 4 in Washington County, Maryland. (Courtesy C&O Canal National Historical Park Headquarters.)

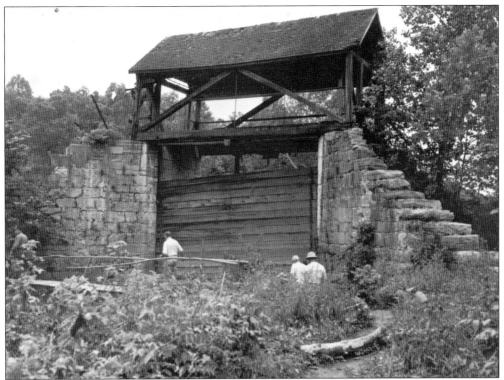

Men explore the old stop gate built over the canal at Dam 4 in Washington County, Maryland. Flooding was often a problem in this area and the stop gate could be lowered to force the rush of water away from the canal and thus provide a measure of protection. (Courtesy C&O Canal National Historical Park Headquarters.)

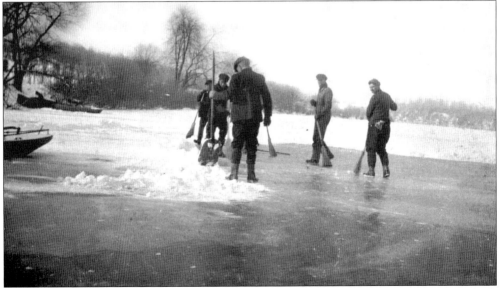

These men are clearing the ice on the C&O Canal at Dam 4 in 1917. Four of the six dams built to supply the canal with water from the Potomac River are located in Washington County. (Courtesy Western Maryland Room Washington County Free Library.)

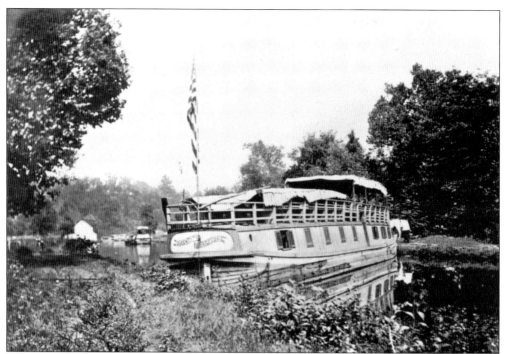

A canal barge is tied up on September 20, 1904, for a break to feed the team at the head of Big Slackwater, which Dam 4 created. Boats left the canal here and were pulled along the river using the bank as a towpath. Boats re-entered the canal at Lock 41. (Courtesy C&O Canal National Historical Park Headquarters.)

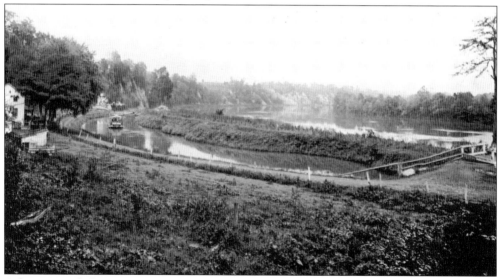

A barge travels between Locks 41 and 42 at the head of Big Slackwater, c. 1920. In places where the Potomac had not cut a wide enough route through the mountainous region, the canal engineers were forced to either tunnel through (as with the Paw Paw Tunnel) or divert traffic into the Potomac River along a "slackwater" for a distance before locking back into the canal. There are two slackwaters and one tunnel on the canal. (Courtesy C&O Canal National Historical Park Headquarters.)

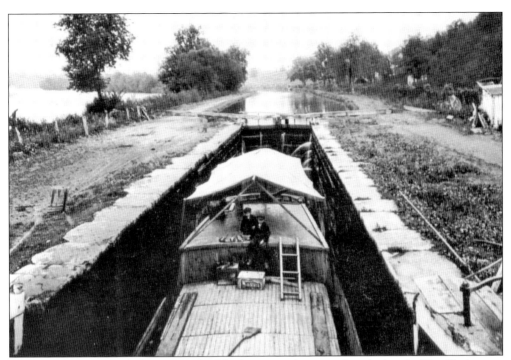

This is a photograph of a boat in Lock 42 looking west (upstream) at the head of Big Slackwater. At this slackwater navigation, canal boats left the canal and traveled on the Potomac River for 3.25 miles before re-entering the canal at the inlet lock, Lock 41. The boys on the boat are polishing the bells for the mules. They also seem to have a pet pigeon in the box on deck. This photo is a good illustration of the different water levels encountered along the canal; note how much lower the water level is in the lock as opposed to the higher water upstream. (Courtesy C&O Canal National Historical Park Headquarters.)

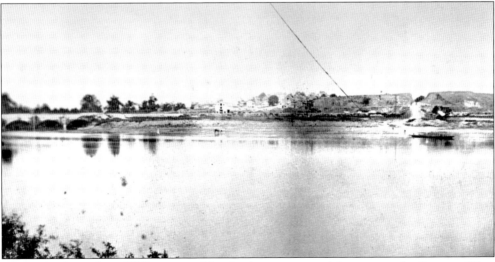

This 1860 photo shows Williamsport, Maryland, as it appeared from across the Potomac River in what, at the time, was the State of Virginia. The spot from which this photo was taken is now West Virginia. Note the ferry line stretching across the river in the photo. (Courtesy C&O Canal National Historical Park Headquarters.)

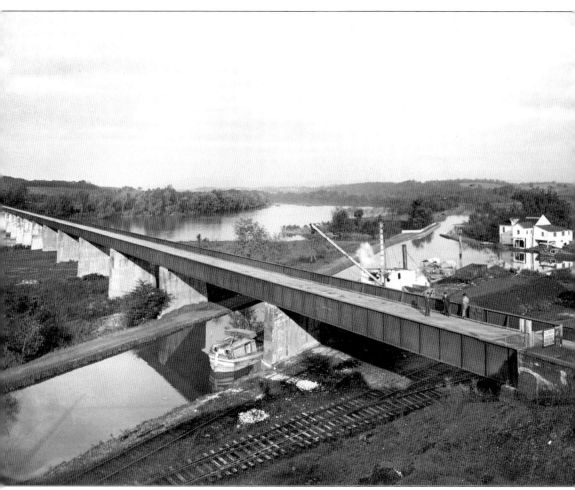

This Consolidated Coal Company photo, c. 1920, shows a bridge across the canal and the Potomac from Williamsport, Maryland, to West Virginia. Dedicated on August 10, 1909, and built at a cost of $100,000, the bridge was originally designed as a toll bridge and charged 25¢ for a horse drawn wagon. The bridge is the only Potomac River bridge between Washington, D.C., and Cumberland to survive the 1936 flood. Note the canal boat passing underneath the bridge and the rail tracks in the foreground. The modern U.S. Route 11 bridge now crosses at this point. Interstate 81 has its own busy bridge crossing within sight. (Courtesy C&O Canal National Historical Park Headquarters.)

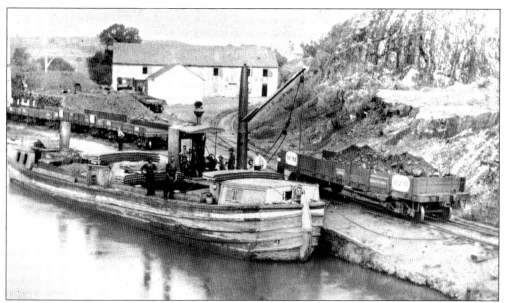

This photo shows one of the rare steam driven canal boats from around 1885. The canal company tried several steamboats as an experiment, but abandoned the idea when it was discovered the boat's high speeds produced a wake that caused excessive washing and erosion of the canal banks. The steam stack can be seen in the middle of the boat in the picture. Note the advertisement on the bow of the boat for Bartholomew's Lager beer. The steam hoist in the picture lifted the bucket while loading the boat, but it was the manual force of the men that pulled it to the right or left as required. (Courtesy C&O Canal National Historical Park Headquarters.)

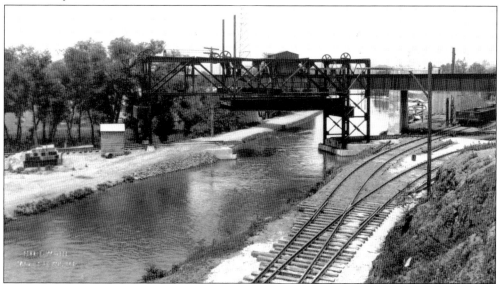

The odd looking contraption in this 1930 photo was a railroad lift-bridge over the C&O Canal in Williamsport, Maryland. Built in 1923–1924, the bridge cost the then-high sum of $100,000, but because the trains quickly cut into the business of the canal, the bridge was never actually utilized. It can still be seen today near the Potomac Edison Plant and the Cushwa Basin on the canal in Williamsport, Maryland. (Courtesy C&O Canal National Historical Park Headquarters.)

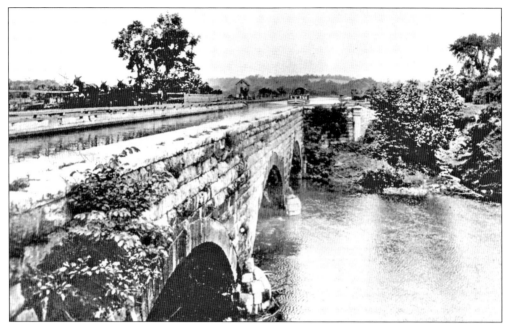

This photo shows a small boat crossing over the Conococheague Creek at Milepost 100 via the Conococheague Creek Aqueduct. Blasting by Mosby's Raiders during the Civil War damaged part of this aqueduct. Today, remnants of the aqueduct can be seen at the Cushwa Basin in Williamsport, Maryland. (Courtesy C&O Canal National Historical Park Headquarters.)

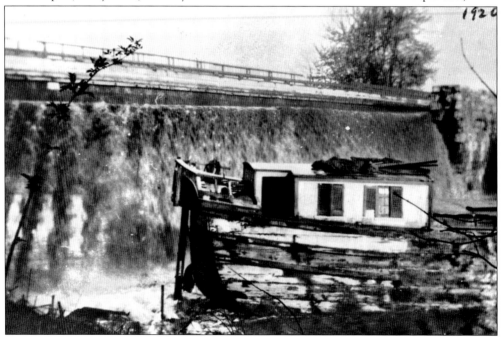

This is a photograph of the Conococheague Aqueduct after its collapse in 1920; note the water spilling out of the canal. The canal boat in the photo struck the upstream wall of the aqueduct and was dumped into the creek when the wall collapsed. (Courtesy C&O Canal National Historical Park Headquarters.)

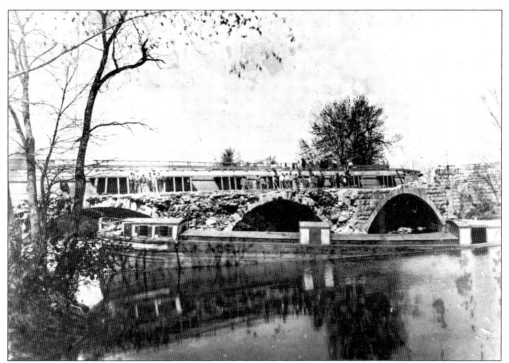

Another view of the collapsed wall of the Conococheague Aqueduct on April 17, 1920, shows a line of people looking down at the canal barge that pitched into Conococheague Creek. The toppled barge remained in the creek until the 1936 flood washed it down the river. A wooden wall was constructed to keep the aqueduct and thus, the canal, in service after the 1920 incident. (Courtesy C&O Canal National Historical Park Headquarters.)

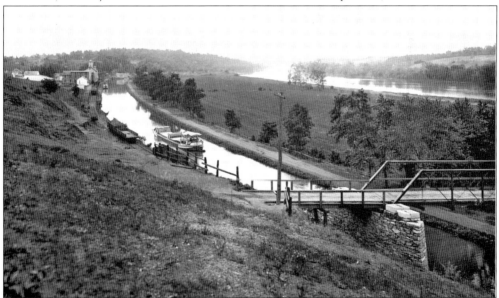

This photo shows Williamsport looking down from Doubleday Hill. The Bowman Bridge is in the foreground and Lockhouse 44 is on the right in the distance. Note the boat in the canal and the river to the right. (Courtesy C&O Canal National Historical Park Headquarters.)

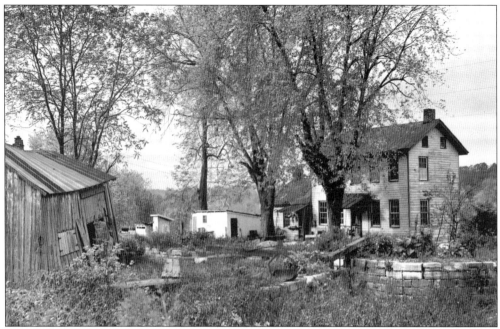

This is Lock 44 and the lockhouse as it appeared in the years after the canal closed. Locktender Avery A. Brant lived in the home at the time the photo was taken. Note how overgrown the canal is; the lock can just be made out in the right foreground. (Courtesy C&O Canal National Historical Park Headquarters.)

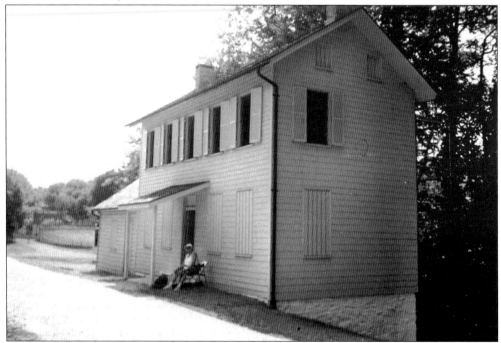

This photo presents a modern view of the unoccupied Lockhouse 44. The interior of the building has marks on the stairway to the second level indicating the height water reached during various floods. (Courtesy Mary H. Rubin.)

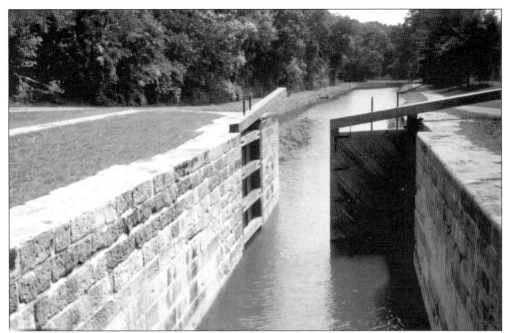

A modern view of the restored lock and gates at Lock 44 in Williamsport shows how the open side of the gate is flush with the lock walls. The indentation in the lock walls can be seen on the right by the closed gate. Canal barges just fit within the confines of the lock so these gate indentations were necessary. (Courtesy Mary H. Rubin.)

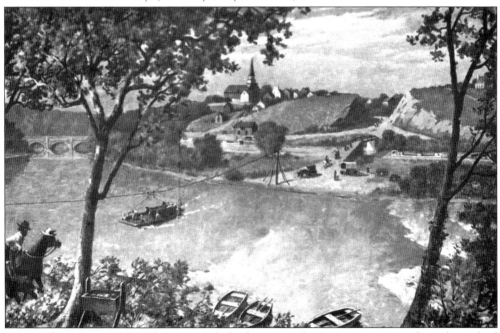

Prior to the construction and opening of a bridge across the Potomac in 1909, the only method of passage from Williamsport, Maryland, to the West Virginia shore was by ferryboat. This oil painting shows a ferry making the crossing. A canal boat can be seen in the middle of the picture as well as an aqueduct to the left. (Courtesy *Maryland Cracker Barrel*.)

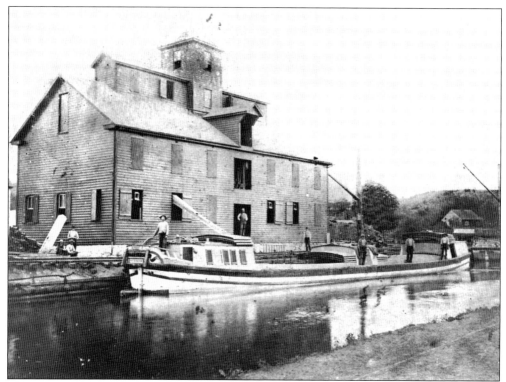

This canal boat is loading at Darby Mill, an old landmark near Lock 44 in Williamsport, Maryland. The mill was destroyed by fire in 1920, just four years before the canal closed. (Courtesy C&O Canal National Historical Park Headquarters.)

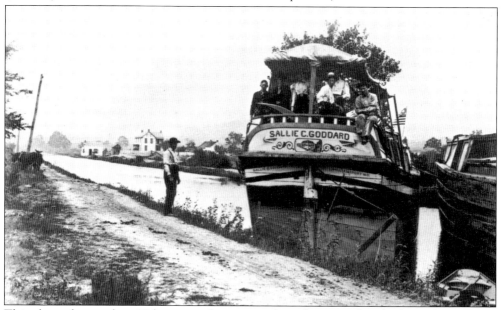

This photo shows a late–19th century boat moored on the towpath. The boat, the *Sallie C. Goddard* of Williamsport, Maryland, was named for the owner's daughter. (Courtesy C&O Canal National Historical Park Headquarters.)

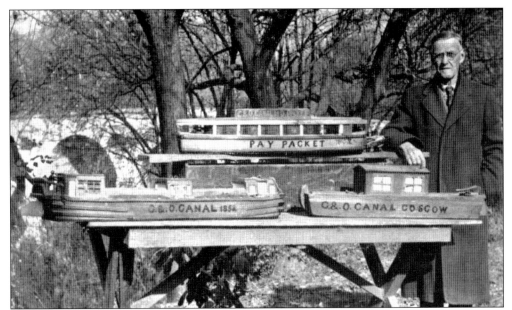

This 1954 photo shows Joseph D. Grove of Williamsport, Maryland, posing with three different models of canal boats that traveled along the canal—a pay packet boat, a work scow, and a standard cargo boat. He handmade all three models in 1930. (Courtesy Western Maryland Room Washington County Free Library.)

This manifest shows a listing of cargo tolls for canal boats from the Cushwa wharves in 1883. Note that the boats each have special names as opposed to the boat numbers that succeeded individual boat naming. (Courtesy Western Maryland Room Washington County Free Library.)

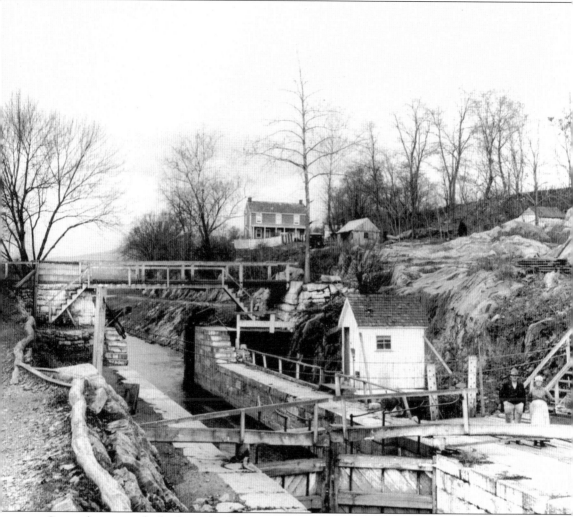

Seven dams were built along the Potomac River to maintain the canal water level. Dam 5, shown here with its guard lock, was responsible for the water level on a 22.3-mile stretch of the canal. During the Civil War the C&O Canal held a dependable position as it carried coal from Cumberland and flour, wheat, and corn from nearby farms to supply Union troops and the nation's capital. Stonewall Jackson planned to cut off this supply line and tried twice in December 1861 to blow up the dam. Union forces held him back, repaired the damages, and kept the boats moving. This lock led boats into Little Slackwater. Lockkeeper Dan Sterling and his wife are standing near the lower gates in this photo. (Courtesy C&O Canal National Historical Park Headquarters.)

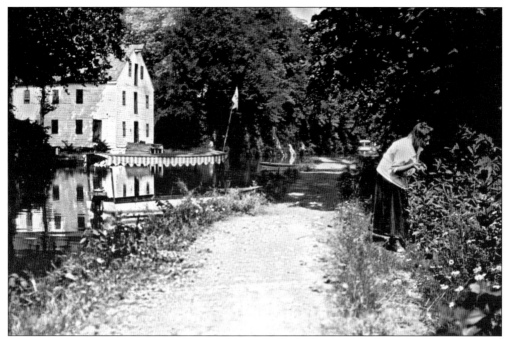

This is a 1916 view of Charles Mill, now known as McMahon's Mill. This Charles Mill should not be confused with the other Charles Mill located near Four Locks at Milepost 108. Mrs. Cowan picks berries along the towpath, and the excursion boat *Sometub*, which cruised to Dam 4, docked behind her near the mill. (Courtesy C&O Canal National Historical Park Headquarters.)

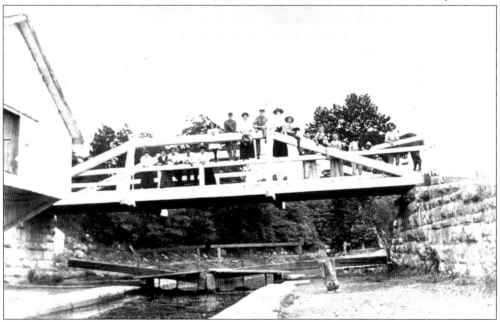

This *c.* 1900 photo from Lock 46 shows a group of people on a mule bridge over the canal. This is one of several places along the canal where the towpath switches from the river side to the land side of the canal, and these bridges allowed the mules to go up and over. (Courtesy C&O Canal National Historical Park Headquarters.)

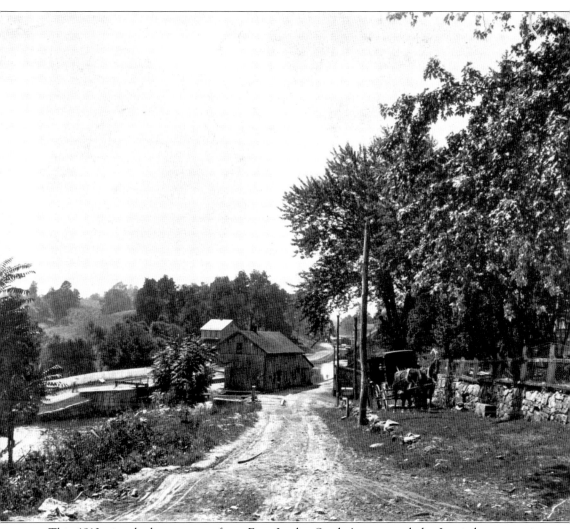

This 1910 view looks upstream from Four Locks. Snyder's store and the Lewis house are in the background while the horse-drawn bookmobile rambles along on the right. Hagerstown librarian Mary Titcomb started the world's very first book wagon service in 1904 when she began using the library wagon to send books to the rural residents of Washington County. The book wagon served as a model for libraries around the world. Service was discontinued during the Great Depression and then again during the gas rationing days of World War II. The original wagon progressed to a specially equipped truck, then to the present day mammoth bookmobile outfitted for the needs of modern patrons. (Courtesy C&O Canal National Historical Park Headquarters.)

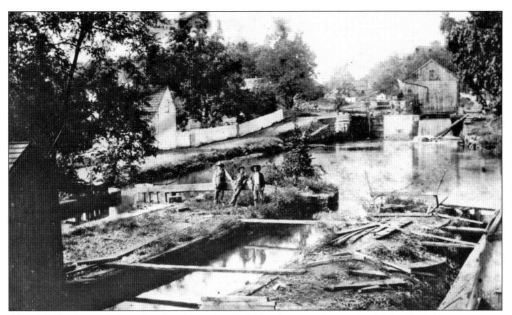

This 1904 photo of Four Locks shows Lock 47 looking upstream to Lock 48. Three men are leaning on the lock gate and to the right is a boat in the dry dock area. The photo was donated to the park service by Fonrose Taylor; he still lived in Lockhouse 49 in 1962. Four generations of Taylors lived in the lockhouse through the years, including Fonrose's grandfather, Samuel Taylor, the last lockkeeper. (Courtesy C&O Canal National Historical Park Headquarters.)

A Consolidated Coal Company photo looks east at Lock 48 at Four Locks. Locks 47 through 50 traverse this area in less than a quarter of a mile and one lockkeeper was officially responsible for all, though it is certain that others in the community helped out. Just below, Locks 45 and 46 make up the area known as Two Locks. One lockhouse served both locks. With the end of the canal, these towns disappeared and remain as memories. (Courtesy C&O Canal National Historical Park Headquarters.)

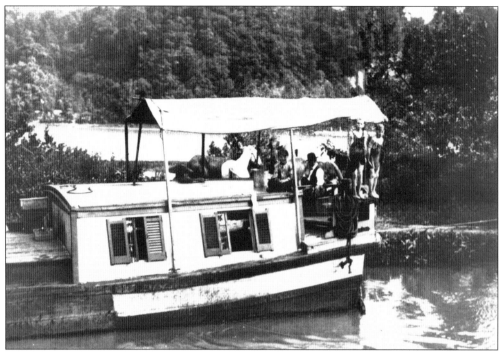

This 1910 scene near Lock 49 at Four Locks shows a pair of boys ready to jump off the barge for a refreshing plunge into the canal. Imagine having a 184.5-mile long swimming pool just outside your front door at any hour of the day! (Courtesy C&O Canal National Historical Park Headquarters, E. B. Thompson Collection.)

Most canal photos show the mules plodding along the canal towpath. This February 17, 1965 photo shows an abandoned mule barn at Lock 50. During the off-season the mules headed to the farms to "winter over." (Courtesy C&O Canal National Historical Park Headquarters.)

This group of schoolchildren is from the Four Locks School. During the heyday of the C&O Canal this area was a thriving village of homes and businesses tied to the commerce of the canal. The canal required the construction of the four locks, Lock 47 through 50, on the short stretch because of a 32-foot change in elevation. When the canal closed in 1924, residents of Four Locks whose families had lived there for generations began to move away as their livelihoods disappeared. The school, known locally as Cedar Grove School, closed in 1943. The school taught eight grades, and a teacher in 1880 was paid $240 per year. (Courtesy C&O Canal National Historical Park Headquarters.)

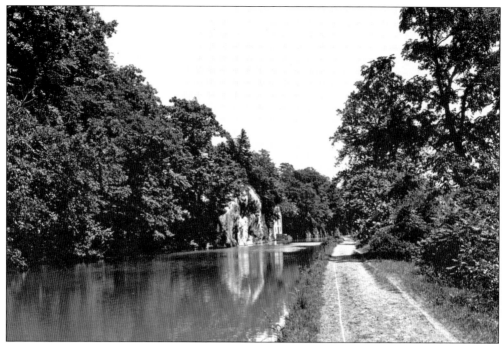

This photo shows the towpath and canal at Charles Mill near Milepost 108. The first mill on this site was built in 1790 and served farmers from the surrounding area. Grain and flour were loaded onto canal boats directly from the mill. The mill remained in the Charles family from the time it was built until closure of the canal in 1924, which also brought about the end of the mill. (Courtesy C&O Canal National Historical Park Headquarters.)

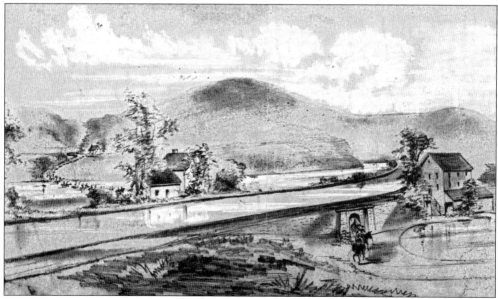

This 1860s Civil War sketch by Theo R. Davis shows the Confederate Cavalry under J.E.B. Stuart crossing the Potomac River at McCoy's ferry just above Iron Mountain and Four Locks. Their intent was to destroy the canal and thus disrupt the supply line it provided for Union forces. (Courtesy C&O Canal National Historical Park Headquarters.)

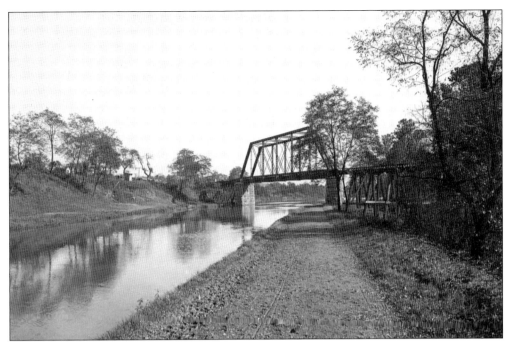

This Western Maryland Railroad bridge is at the head of Big Pool—actually a 1.5-mile lake created by canal engineers. This area is one of the few parts of the canal above Violette's Lock to still be watered. (Courtesy C&O Canal National Historical Park Headquarters.)

This photo of Fort Frederick State Park was taken in 1938. Construction of the fort began in 1756 in response to settler's concerns of impending attacks by Native Americans during the French and Indian War. The fort was later used during the Revolution to house prisoners of war and during the Civil War to guard the C&O Canal and the Western Maryland Railroad. (Courtesy C&O Canal National Historical Park Headquarters.)

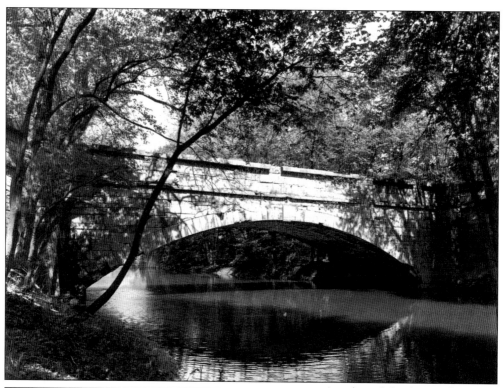

Another of the 11 aqueducts required along the length of the canal is the single arch limestone Licking Creek Aqueduct shown from the river side in this April 1961 photo. (Courtesy C&O Canal National Historical Park Headquarters.)

This peaceful scene of Little Pool looks upstream. (Courtesy C&O Canal National Historical Park Headquarters.)

Four

HANCOCK TO CUMBERLAND

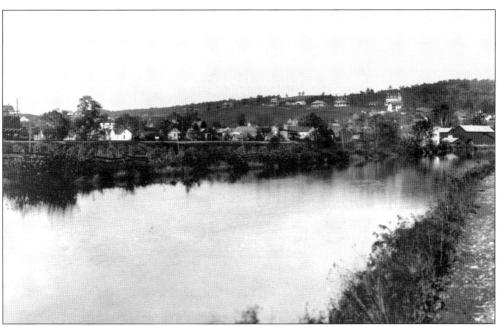

Hancock, Maryland, was a major stop on the route west along the National Road. Many canal families also "wintered over" in Hancock, living on their docked boats until it was time to begin traveling up and down the canal again in the spring. The Hancock town seal acknowledges the town's link to the canal with an image of mules pulling a canal barge. (Courtesy C&O Canal National Historical Park Headquarters.)

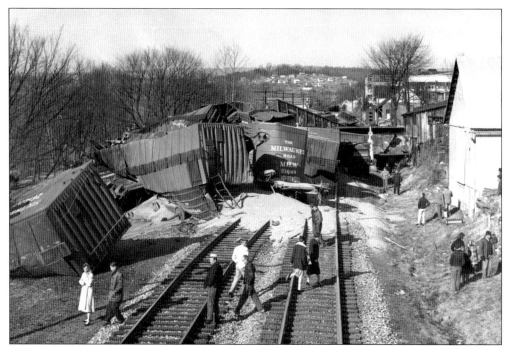

The railroads and the canal share a great deal of history. This photo, taken February 20, 1959, shows a Western Maryland Railroad wreck at Hancock, Maryland. The white substance all over the tracks is wheat from the damaged rail cars. (Courtesy C&O Canal National Historical Park Headquarters.)

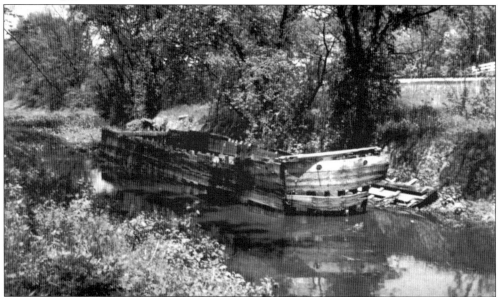

Taken in 1958, this photo shows the sad remains of boat #57 on the C&O Canal in Hancock, Maryland. The government acquired the canal in 1938, but it was not declared a National Monument until 1961. Created as a National Historic Park in 1971, it is a popular spot for hiking, biking, camping, boating, fishing, and many other recreational activities. (Courtesy Western Maryland Room Washington County Free Library.)

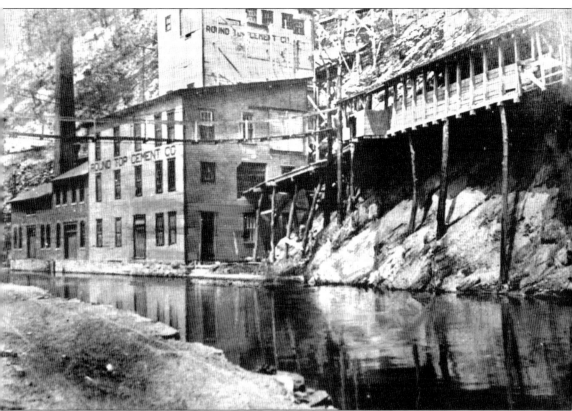

The Round Top Cement Company was located near Hancock, Maryland. Built in 1838, the mill was originally constructed to supply cement to complete the western end of the canal. The mill employed around 100 workers who packed the cement in 300-pound barrels and 50- and 100-pound sacks. The plant remained in operation after the end of canal construction in 1850, but by the end of the 1800s natural cement was surpassed by the stronger Portland Cement. Plant output declined, resulting in the close of the company in 1909. (Courtesy C&O Canal National Historical Park Headquarters.)

Located along the dried canal bed above the Roundtop Cement Company ruins is this fold in the rock strata known as the Devil's Eyebrow anticline. (Courtesy C&O Canal National Historical Park Headquarters, photo by Abbie Rowe.)

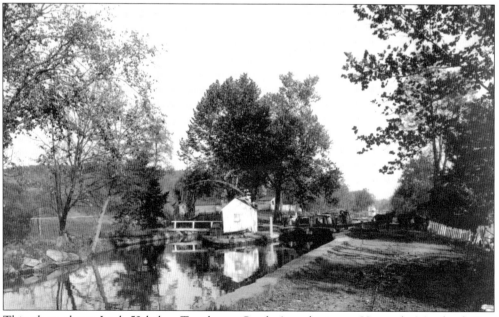

This photo shows Lock 52 below Tonoloway Creek Aqueduct near Hancock, Maryland. Fort Tonoloway was built near here in 1755. The log structure was used as a blockhouse and stockade. The fort was abandoned in 1756 when the stronger Fort Frederick was erected. (Courtesy C&O Canal National Historical Park Headquarters.)

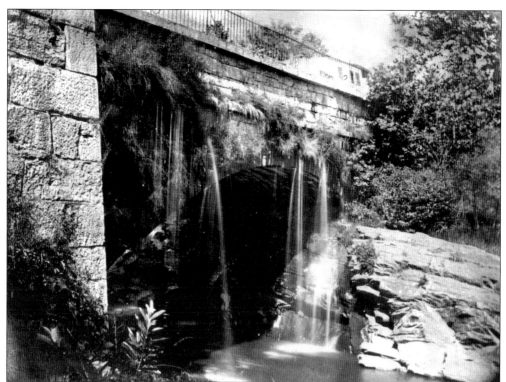

This is a photo of the Tonoloway Creek Aqueduct crossing over the canal just below Hancock, Maryland. (Courtesy C&O Canal National Historical Park Headquarters.)

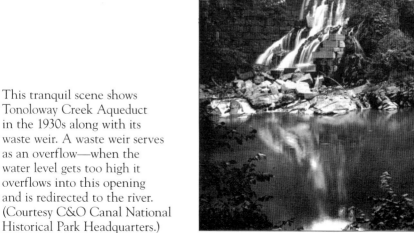

This tranquil scene shows Tonoloway Creek Aqueduct in the 1930s along with its waste weir. A waste weir serves as an overflow—when the water level gets too high it overflows into this opening and is redirected to the river. (Courtesy C&O Canal National Historical Park Headquarters.)

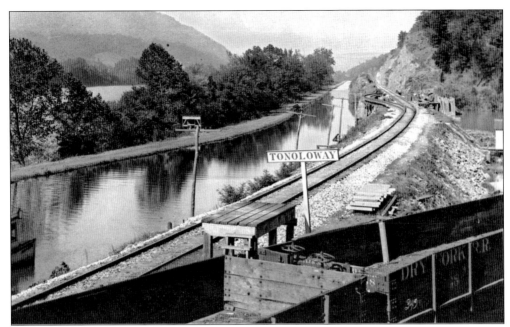

Dam 6 at Tonoloway was photographed in 1920 by the Consolidated Coal Company. Note the rail tracks running right next to the canal. The railcars read "Dry Fork Railroad." Polly Pond is on the right. Dam 6 was another Confederate target during the Civil War. (Courtesy C&O Canal National Historical Park Headquarters.)

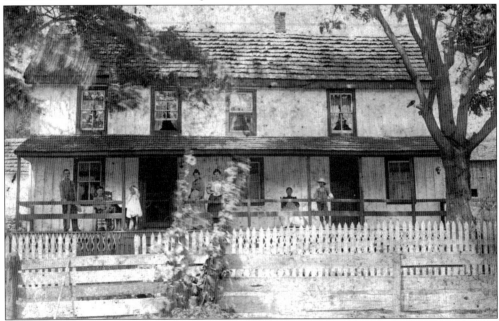

Lock 56, the last lock of the C&O Canal in Washington County, was located in the small town of Pearre between Sidling Hill and Tonoloway Ridge. This *c.* 1890 photo shows lockkeeper Thomas F. Donegan with some of his family in front of his canal home—the large house was necessary to accommodate his 13 children! (Courtesy C&O Canal National Historical Park Headquarters.)

Feeder Dam 6 was the farthest point on the canal in 1842 and stayed that way for eight years when construction was stopped for lack of funds. Later, during the Civil War, Confederate troops tried several times to demolish this dam and thus disrupt canal traffic and the supply line it provided. (Courtesy C&O Canal National Historical Park Headquarters.)

The Consolidated Coal Company took this 1920 photo of Lock 58 above Little Orleans, Maryland. Little Orleans lies at the mouth of Fifteen Mile Creek at Milepost 140. In the late 1700s the road through Little Orleans was the main route from Fort Cumberland to Fort Frederick. Fifteen Mile Creek was so named because in 1760 it was 15 miles from Town Creek and 15 miles from Hancock. (Courtesy C&O Canal National Historical Park Headquarters.)

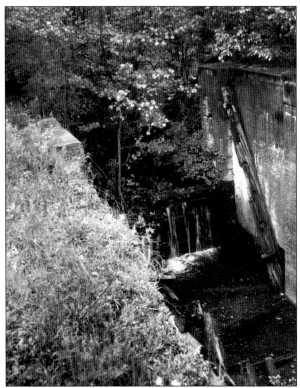

Lock 65 was never built and the two locks prior to it find themselves with odd nomenclatures; this photo, for instance, shows Lock 63 1/3. The photo was taken June 2, 1956, from below the Paw Paw Tunnel looking upstream prior to a clearing of the area. (Courtesy C&O Canal National Historical Park Headquarters, photo by Abbie Rowe.)

Below is a photo of the other "fractional" lock, 64 2/3. This numbering system is a result of the canal company's need to retain their numbering system after the decision not to build Lock 65; the numbering is supposed to compensate for the missing lock by incrementing lock numbers by 1 1/3 rather than 1, thus Locks 62, 63 1/3, 64 2/3, and 66. (Courtesy C&O Canal National Historical Park Headquarters.)

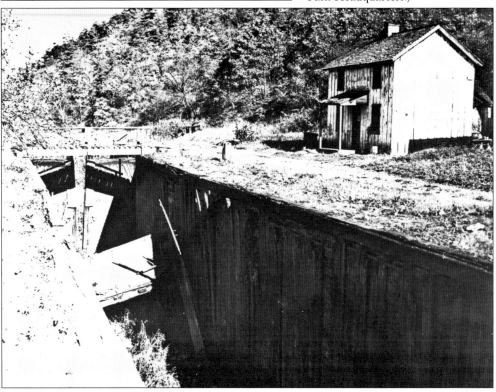

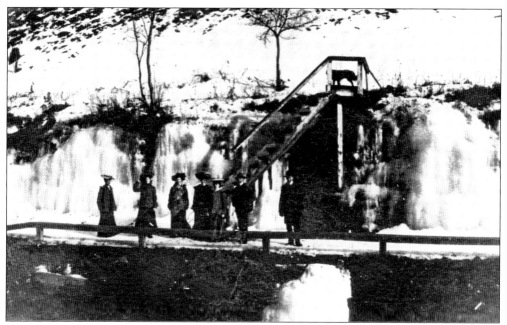

Taken *c.* 1900, this photo shows Tom Woodley, Jack Matthews, Julia Cavanaugh, and four Kiefer girls near the steps that led to a spring below the Paw Paw Tunnel. Note the ice-covered areas in this winter photo. (Courtesy C&O Canal National Historical Park Headquarters.)

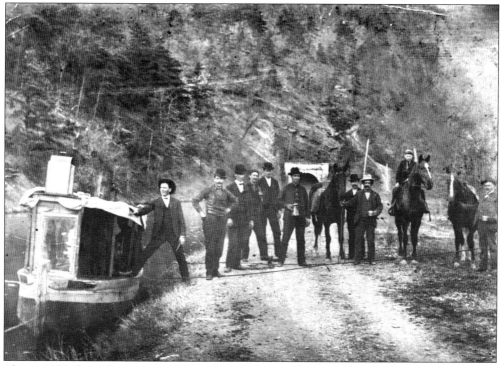

This *c.* 1900 photo shows men in their pleasure boat in front of the Paw Paw Tunnel. The Paw Paw is actually a fruit from a large leafed tree that, because of its softness, is not commercially grown. (Courtesy C&O Canal National Historical Park Headquarters.)

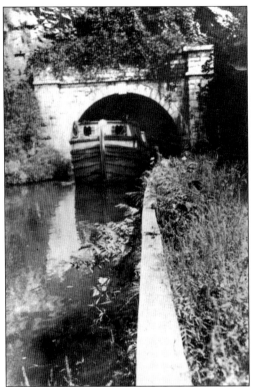

This classic photo from 1918 shows boat #52, captained by Jas. Null, exiting from the upstream portal of the 3,118-foot-long Paw Paw Tunnel. Construction of the tunnel began in 1836 with expected completion in 1838. However, the tunnel was not completed until 1850. (Courtesy C&O Canal National Historical Park Headquarters, Hooper Wolfe Collection.)

The Men's Club poses at the east portal of the Paw Paw Tunnel during an 1880s excursion. The Paw Paw was a favorite excursion point from Cumberland. Legend goes that picnickers from churches went to North Branch or Spring Gap, but heavy drinkers went to Paw Paw. (Courtesy C&O Canal National Historical Park Headquarters, Herman Miller Collection.)

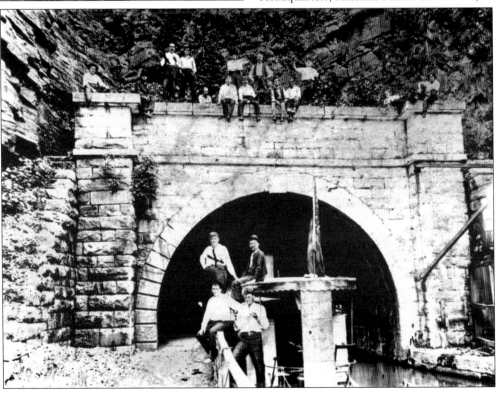

This 1938 photo of the western portal shows how the Paw Paw Tunnel area fell into decline after the canal closed. (Courtesy C&O Canal National Historical Park Headquarters.)

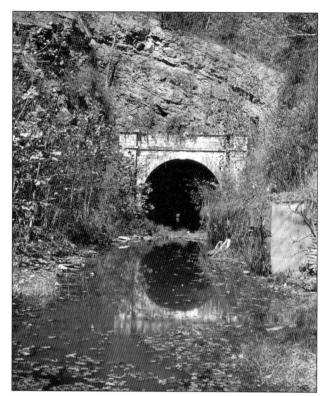

This August 22, 1956 photo shows some of the men and equipment used during the Paw Paw Tunnel restoration work. (Courtesy C&O Canal National Historical Park Headquarters.)

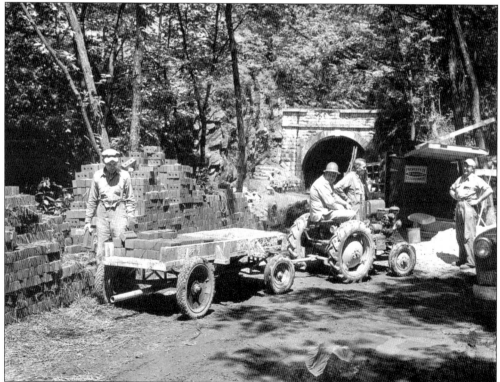

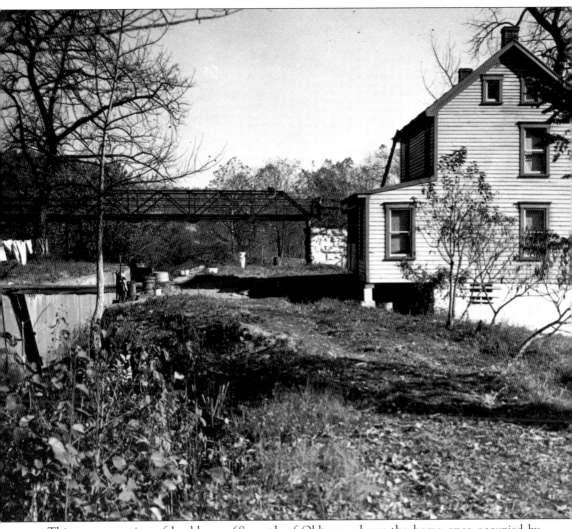

This upstream view of Lockhouse 68, south of Oldtown, shows the home once occupied by Isaac Long. His rent was $3 per month! Just above Lock 68 at the point where the Potomac River splits into two branches, North and South, the canal follows the North Branch, generally referred to simply as the Potomac. The North Branch is wider and the South is longer; a dispute ensued over which was the "true" Potomac and, thus, the border between Maryland and Virginia (now West Virginia). If the North Branch had not been settled on, Maryland would have quite a different shape today! This lock is also the site where Dam 7 would have been built, but construction never took place. (Courtesy C&O Canal National Historical Park Headquarters.)

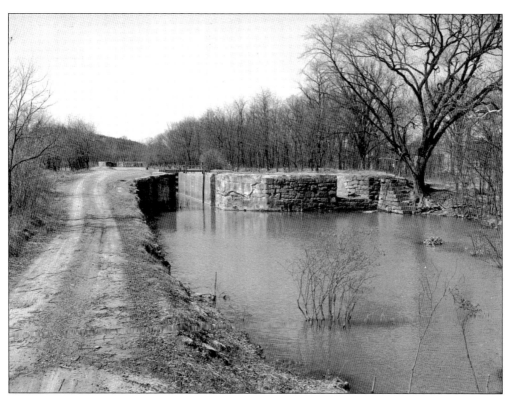

This upstream photograph shows Lock 69 (Twigg's Lock) in the foreground with Lock 70 in the distance after the towpath was cleared of overgrowth and debris. (Courtesy C&O Canal National Historical Park Headquarters, photo by Abbie Rowe.)

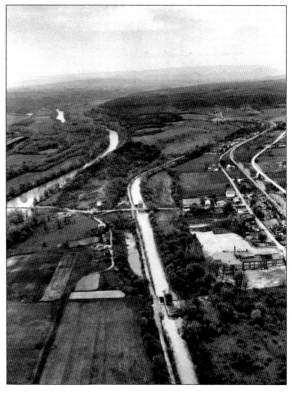

This is an aerial view of the Oldtown, Maryland area. Note the canal locks in the middle and the river snaking off to the left. After a Confederate battle in Chambersburg, Pennsylvania, some Civil War activity moved to this area. (Courtesy C&O Canal National Historical Park Headquarters, photo by Abbie Rowe.)

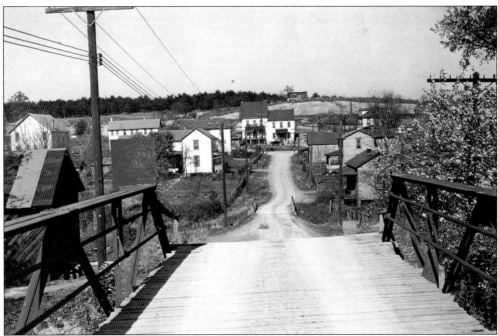

This is a view of Oldtown, Maryland, as seen from the bridge over the C&O Canal. Oldtown was settled by Shawnee Indians in 1642 and was later made into a fortified settlement (Fort Skipton) by Thomas Cresap (founder of Cresaptown.) (Courtesy C&O Canal National Historical Park Headquarters.)

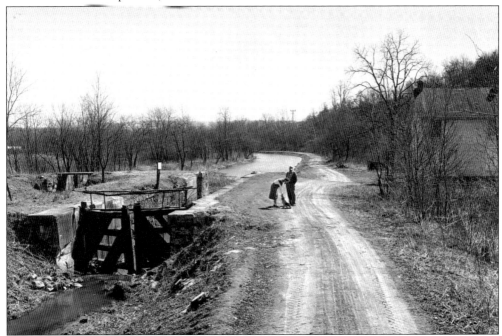

Lock 71 in Oldtown is photographed with a man, woman, and well-behaved dog on the towpath. The lockhouse itself is obscured by the trees on the right. This photo was taken after the area was cleared. (Courtesy C&O Canal National Historical Park Headquarters.)

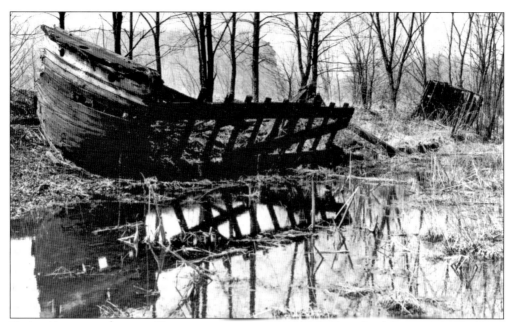

Spring Gap, once the site of boat excursions from Cumberland, and a deteriorating canal boat are shown in ruins. (Courtesy C&O Canal National Historical Park Headquarters, Herman J. Miller Collection.)

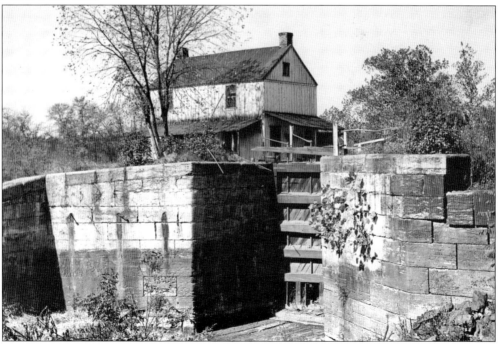

This frame house was located at Lock 72, south of the North Branch in western Maryland. This lock is also known as Ten Mile Lock since it is just 10 miles from Cumberland, Maryland. At one time the home was occupied by Mark Fazenbaker; his rent was only $5 per month! An early locktender's pay was $150 per year, plus the use of a garden plot. (Courtesy C&O Canal National Historical Park Headquarters.)

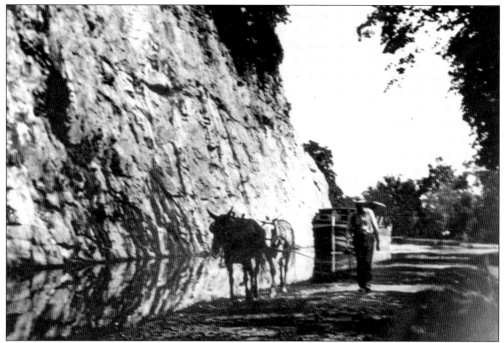

This photo shows a man and his mules pulling his barge along level 72, through the area known as the Narrows. Named for obvious reasons, the high rocks from the ends of Nicholas Ridge and Irons Mountain can be seen on the opposite side of the canal from the towpath. (Courtesy C&O Canal National Historical Park Headquarters.)

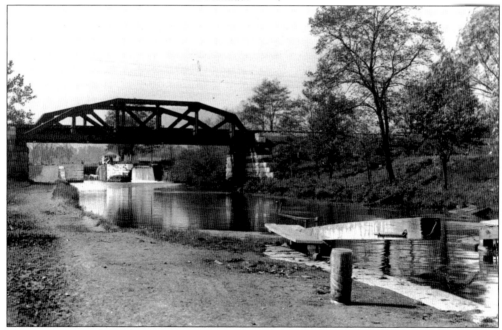

This 1920 Consolidated Coal Company photo shows the ever-present railroad, inextricably linked to the canal. This Western Maryland Railroad bridge runs between Locks 73 and 74 near North Branch, Maryland. (Courtesy C&O Canal National Historical Park Headquarters.)

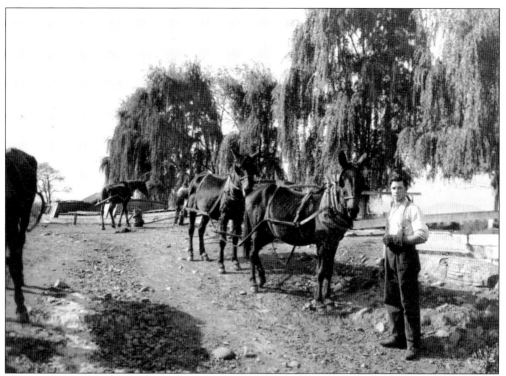

In 1920 the Consolidated Coal Company photographed a man with his team of mules at the foot of Lock 75 at the Cumberland level. His canal boat is in the background of the photo. (Courtesy C&O Canal National Historical Park Headquarters.)

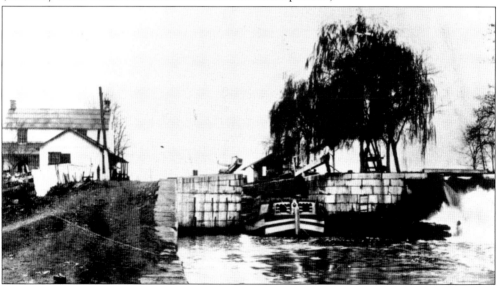

A canal boat exits Lock 75 and travels downstream. Lockhouse 75, the westernmost lock on the canal, is partially obscured on the left of the photo, the lockkeeper's shed is toward the center of the photo, and a bypass flume is on the far right. There were two footbridges—one over the bypass flume and one over the canal. (Courtesy C&O Canal National Historical Park Headquarters.)

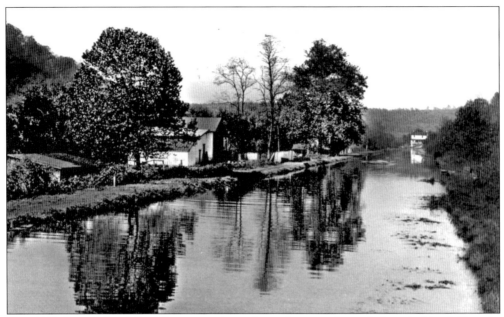

This 1920 Consolidated Coal Company photo shows the pump house below the North Branch. During construction, it was initially thought that Dam 7 could be omitted because of the large amount of water in the Cumberland Basin; however, it was discovered that the canal did not get enough water to reach Dam 6. The water pumping station was put in to supply the lower levels at the "Blue Spring," a large ever-flowing spring. This spring was also the site of the Opening Day picnic celebrations by the canal company officials in 1850. (Courtesy C&O Canal National Historical Park Headquarters.)

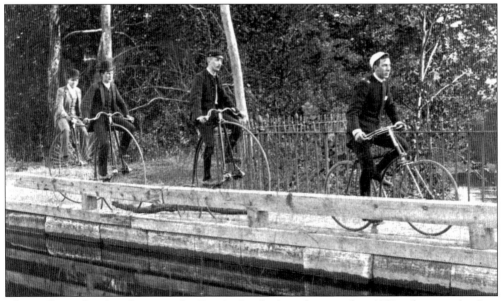

The Willison family rides over the Evitt's Creek Aqueduct in this 1870s photograph. One of the men is riding a small wheel Schwinn bicycle while the other three men are on old "high wheelers" as they free wheel along the path. (Courtesy C&O Canal National Historical Park Headquarters.)

Note the size of those icicles hanging down from the aqueduct that spanned Evitt's Creek near Milepost 180. (Courtesy C&O Canal National Historical Park Headquarters.)

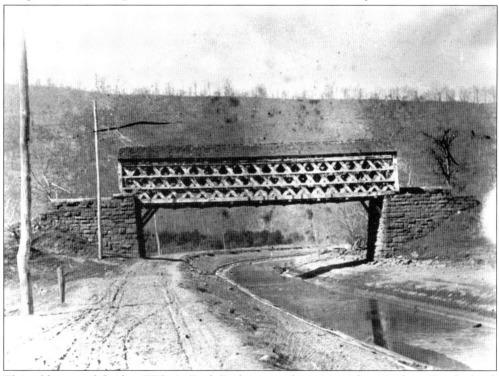

This old covered bridge, Wiley's Ford Bridge, stretches across the canal in Cumberland, Maryland. (Courtesy C&O Canal National Historical Park Headquarters.)

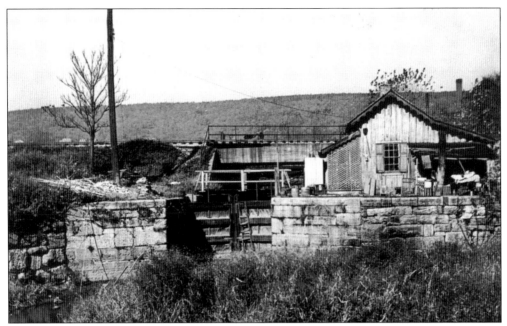

This photo, taken in the 1940s, shows the Twin Guard Locks at the canal terminus in Cumberland. One of the locks let water into the basins while the other allowed boats to pass to and from the river. Note the rail bridge built on the foundations of the filled in locks. Skat Eaton and his family lived in the lockhouse until it was torn down in 1957. For a time after the canal closed in 1924, the family lived in their docked canal boat just as many others did. (Courtesy C&O Canal National Historical Park Headquarters.)

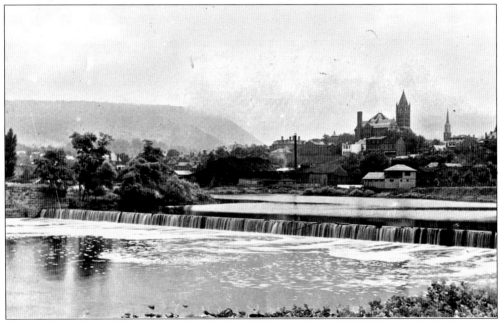

This is Dam 8, a roller dam, in Cumberland, Maryland, in 1900. The town's skyline rises in the background. (Courtesy C&O Canal National Historical Park Headquarters, E.B. Thompson Collection.)

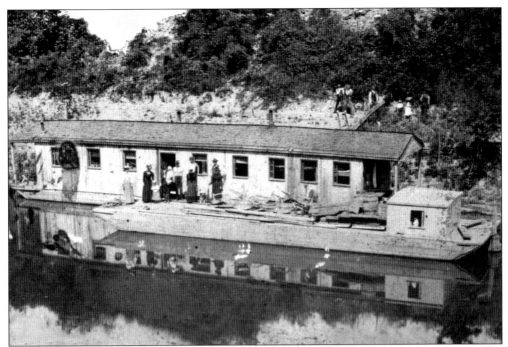

A canal maintenance barge floats on the canal near Cumberland, Maryland, c. 1900. Founded in 1787, Cumberland holds an important position in canal history; not only is it the farthest western point along the canal and thus the loading point for Georgetown-bound cargo, but boatyards in Cumberland built many of the boats that traveled the canal. (Courtesy C&O Canal National Historical Park Headquarters.)

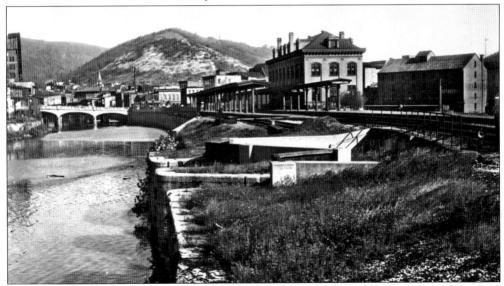

This photograph shows the terminus of the C&O Canal at Wills Creek in Cumberland, Maryland. The Western Maryland Railroad terminal and tracks are to the right of the canal. Today, the train station, built in 1910, serves as the Cumberland C&O Canal Visitor's Center as well as a Western Maryland Railroad Museum. (Courtesy C&O Canal National Historical Park Headquarters.)

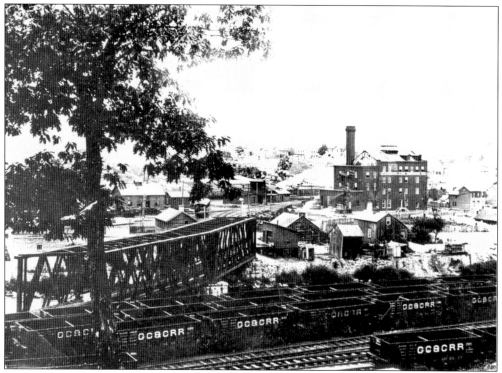

A *c.* 1900 view of the canal terminus at Cumberland, Maryland, shows the Consolidated Coal Company's rail lines to the boat basin. (Courtesy C&O Canal National Historical Park Headquarters.)

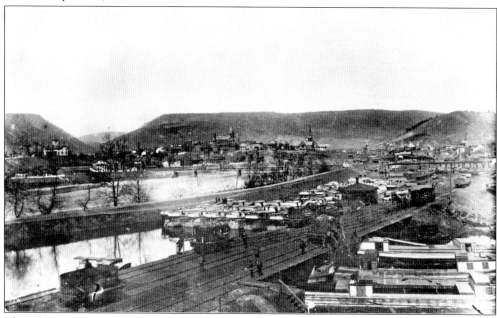

This photo, *c.* 1900, shows the busy canal boat and coal wharf in Cumberland, Maryland. In spite of initial plans to build all the way to Pittsburgh, the canal ended here in 1850 and was never extended farther west. (Courtesy C&O Canal National Historical Park Headquarters.)

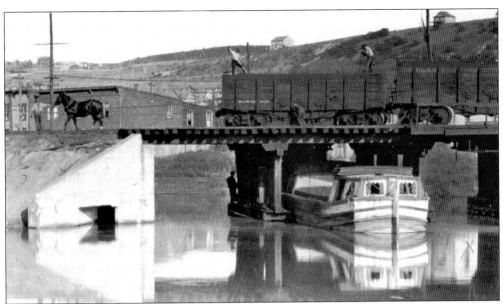

This is a 1912 photo of the Consolidated Coal Company loading wharf. The coal trade was the main profit operation for the canal. During 1875, the peak year of operation, the canal transported 904,898 tons of Cumberland coal. After the floods of 1889, the canal began carrying coal almost exclusively. Prior to that time, products from mills and manufacturing centers such as those near Williamsport, Weverton, and Georgetown were also important canal cargoes. Note the rail cars on the tracks over the canal. (Courtesy C&O Canal National Historical Park Headquarters.)

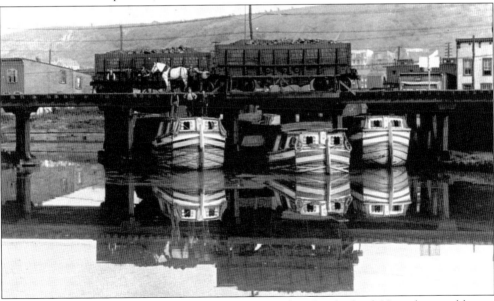

This is a view of the Consolidated Coal Company yard in Cumberland. Note the canal barges waiting under the rail tracks. It took about one hour to load a canal boat with coal. Coal came down a chute from the rail car above, feeding the coal into the large cargo hold of the barge. It took about five hours to unload the coal when the boat reached its destination. (Courtesy Western Maryland Room Washington County Free Library.)

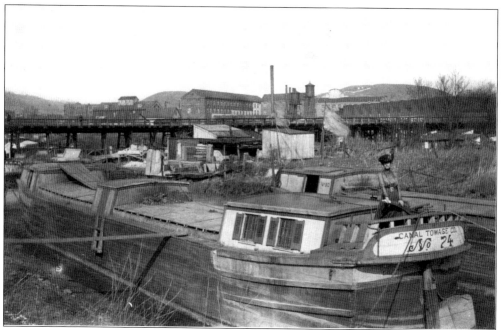

This is Canal Towage Company boat #24 in June 1910 at Cumberland, Maryland. The family quarters are in the back with the windows, and the mules were stabled in stalls below the front deck. When Canal Towage began supplying the canal boats, the days of each boat having a unique name faded into the past; the boats began to carry a simple boat number instead. (Courtesy C&O Canal National Historical Park Headquarters.)

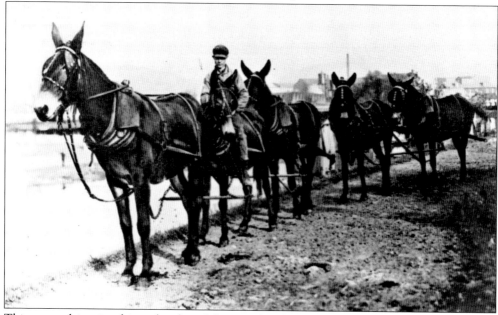

This young driver is taking a break with his canal mules near Cumberland, Maryland, in 1920. The original photo caption included the comment "the mules were often cantankerous and able to kick a chaw of tobacco out of a man's mouth three rods off." (Courtesy C&O Canal National Historical Park Headquarters.)

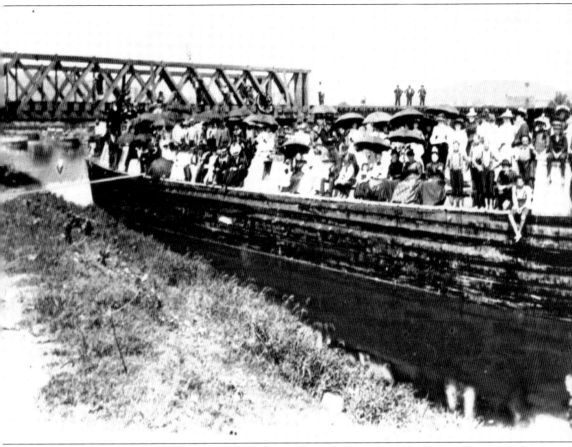

A Cumberland group enjoys a Sunday outing on the canal in the 1880s. Note the railroad bridge in the background. The notation on the back of the original photograph stated the people were waiting for the "con" man who claimed he could walk on water, but walked out of town instead. Construction of the Baltimore and Ohio railroad began on the same day as the canal, yet it reached Cumberland eight years prior to the canal, thus making the canal's technology antiquated the day it was completed. (Courtesy C&O Canal National Historical Park Headquarters.)

This photo, c. 1910, shows the Shantytown area of Cumberland, Maryland, at the Wineow Street canal terminus. Note the canal barges crowded in the background, the rail tracks on the left, and the area buildings, which include saloons and pool parlors, on the right. (Courtesy C&O Canal National Historical Park Headquarters.)

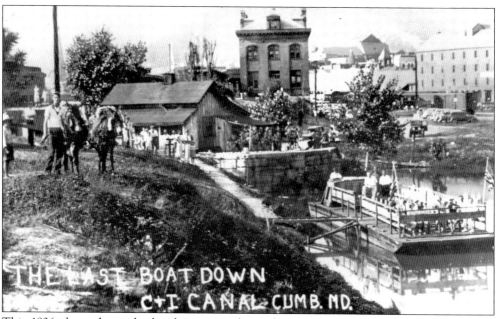

This 1936 photo shows the last boat to go down the C&O Canal as it leaves Cumberland, Maryland. The canal ceased operations in 1924 after a devastating flood forced the closure of what had already become an outdated mode of commerce. (Courtesy C&O Canal National Historical Park Headquarters.)

Five

ONE MORE LOOK

This statue of a young mule driver, sometimes called a "hoggee," and his mule "Daisy" stands in front of the C&O Canal Visitor's Center in Cumberland. Considering that the railroads helped bring about the end of the canal, it is ironic that the visitor's center is located in the old Western Maryland Railroad Station! (Courtesy Mary H. Rubin.)

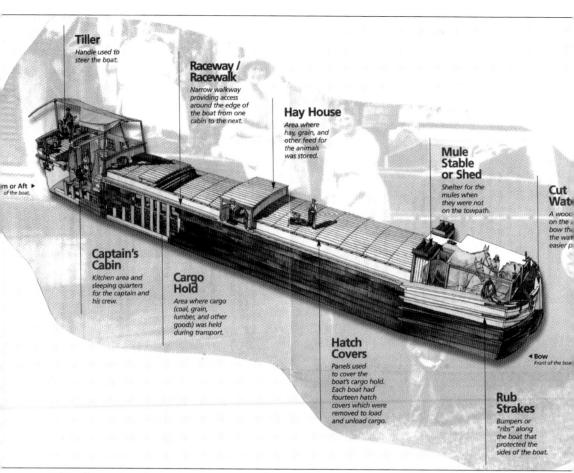

Tiller
Handle used to steer the boat.

Raceway / Racewalk
Narrow walkway providing access around the edge of the boat from one cabin to the next.

Hay House
Area where hay, grain, and other feed for the animals was stored.

Mule Stable or Shed
Shelter for the mules when they were not on the towpath.

Cut Wate
A wood on the bow th the wat easier p

rn or Aft ►
of the boat.

Captain's Cabin
Kitchen area and sleeping quarters for the captain and his crew.

Cargo Hold
Area where cargo (coal, grain, lumber, and other goods) was held during transport.

Hatch Covers
Panels used to cover the boat's cargo hold. Each boat had fourteen hatch covers which were removed to load and unload cargo.

Rub Strakes
Bumpers or "ribs" along the boat that protected the sides of the boat.

◄ **Bow**
Front of the boa

This illustration shows a cross section of a canal boat along with descriptions of the various sections. Boats cost around $1,400 to build with the mule teams and equipment needed to outfit it added to the total. The average life span of a canal boat was ten years. Boat yards often financed the purchase of the boat, but the canaller had to agree to ship cargo exclusively for firms the boat builder selected. (Courtesy C&O Canal National Historical Park Headquarters.)

Two canal mules have a nibble in this June 20, 1904 photo. The original photographer included a caption on the photo that asked, "In storm, in sunshine or in rain!" This is similar to today's postal delivery creed: "neither wind nor rain nor dark of night, will stray them from their appointed rounds." (Courtesy C&O Canal National Historical Park Headquarters.)

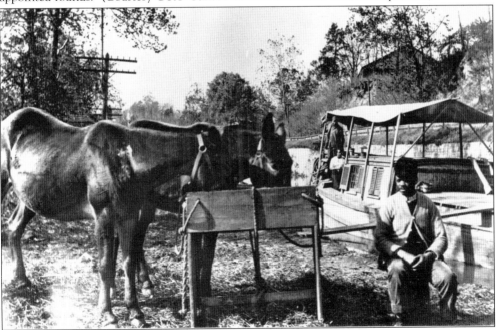

African Americans worked as deckhands on canal boats in the early canal days, but were banned from owning a boat until after the Civil War. There were four African-American boat captains during the 1870s, but by the final years of the canal only one African-American canal boat family was still listed. This c. 1910 photo shows a family above Georgetown waiting to unload. The C&O Canal also played a role in the Underground Railroad during the Civil War. (Courtesy C&O Canal National Historical Park Headquarters, E.B. Thompson Collection.)

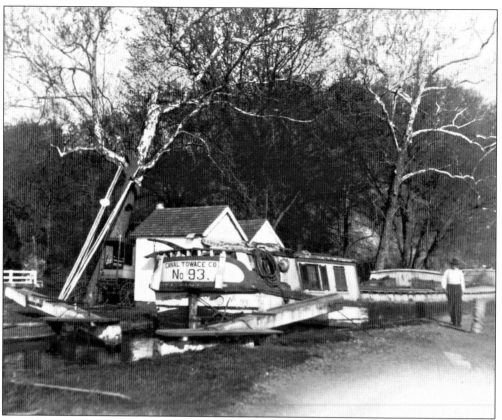

Canal Towage Boat #93 is loaded full in a lock in 1900. It was easy to tell a fully loaded boat because it rode much lower in the water than empty ones. Boats often came from Cumberland heavily laden and made the return trip up the canal virtually empty. (Courtesy C&O Canal National Historical Park Headquarters.)

Prior to the Civil War, the United States did not have a true national currency—paper money was issued by state banks. Some of these banks helped finance canal construction. While intricately engraved, the money was easy to counterfeit. This C&O Canal banknote dated September 9, 1840, was good for "Five Dollars plus interest." Note the elaborate artwork adorning the note. (Courtesy C&O Canal National Historical Park Headquarters.)

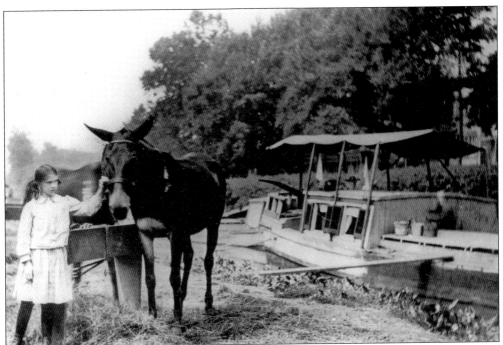

This photo shows a young girl with one of the family's mules next to the tied up canal barge. One of the first jobs of canal children was to care for the mules that pulled the boats. Because the mules were vital to the family livelihood, they were well fed and had their own quarters in the front of the boat for rest periods. Teams worked six hour rotations; they were unhitched and led into their shady stalls during off hours. Teams often switched while a boat was "in lock." (Courtesy C&O Canal National Historical Park Headquarters.)

This c. 1900 photo shows moving day on the canal as a family moves from one canal boat to another. (Courtesy C&O Canal National Historical Park Headquarters.)

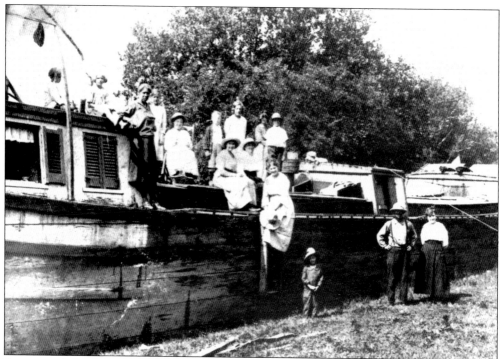

Some canal families enjoy a Sunday layover in 1920. This was a time to relax and entertain friends and family. (Courtesy C&O Canal National Historical Park Headquarters.)

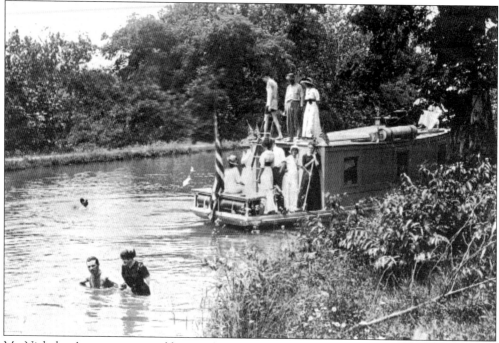

Mr. Nickolson's paymaster canal boat is shown in this 1920 photograph. Mr. Nickolson is in the water in the foreground. Perhaps this was a Sunday afternoon family gathering for some fun and relaxation. (Courtesy C&O Canal National Historical Park Headquarters.)

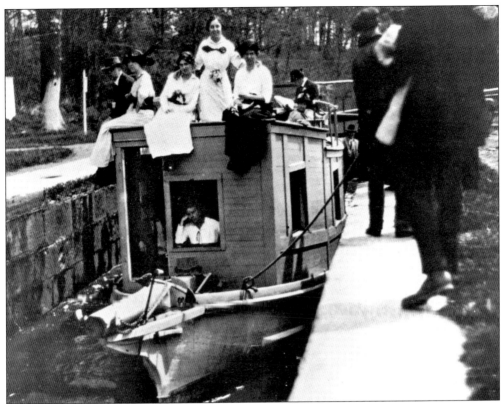

A group of happy boaters enjoys a Sunday outing on a geological survey boat. Note the tight fit of the boat through the canal lock. (Courtesy C&O Canal National Historical Park Headquarters.)

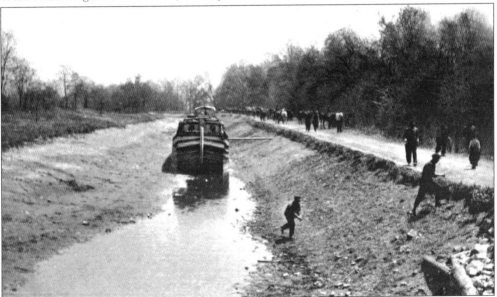

During times of too little water, travel along the canal was impeded. This old photo shows a dried section of the canal with a stranded barge in the mud. (Courtesy C&O Canal National Historical Park Headquarters.)

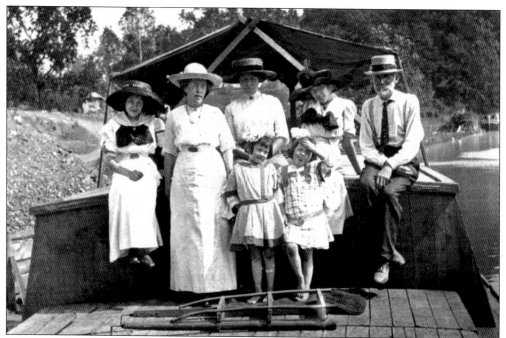

A canal family poses on their boat dressed in their Sunday best. Canal life involved long, hard hours of work for the entire family. Children as young as six were considered able to help and were often given the job of tending the mules. The entire family lived in the 12-by-12.5-foot cabin as they traveled up and down the 184.5-mile length of the canal from March to December of each year. (Courtesy C&O Canal National Historical Park Headquarters.)

Two women look out of the windows of this Canal Towage Company boat. Family quarters on the boats were small but neat with built in bunks in the cabin. (Courtesy C&O Canal National Historical Park Headquarters.)

This early 1900s photo shows daily life along the canal. Note the local dog stopping for a refreshing drink from the canal. (Courtesy C&O Canal National Historical Park Headquarters.)

Built in 1831 by Phineas Davis, the *York* was the first practical locomotive used on the Baltimore and Ohio Railroad. The B&O, the first railroad in the United States, was started in 1828, the same year as the canal, yet the railroad reached Cumberland first, making the canal already obsolete. Thus began the rivalry between the railroad and the canals. (Courtesy C&O Canal National Historical Park Headquarters.)

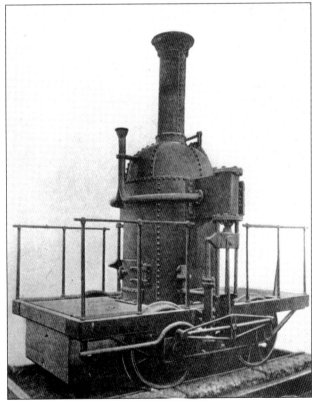

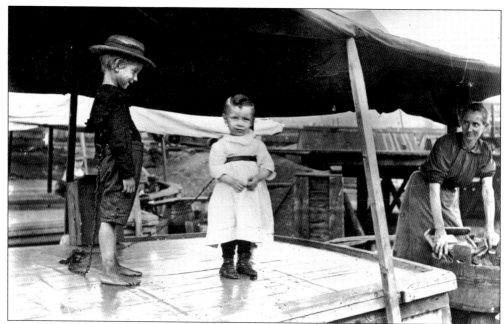

At first glance this *c.* 1910 photo seems a strange scene—the two children are in harnesses that are chained to the deck of the canal boat. The harness, however, served as a protective device for the children while their parents were busy with the operation of the canal boat. The harnesses were intended to keep the children from wandering into danger or toppling over the side of the boat into the canal. The mother stands to the right, watching her children while she does laundry. (Courtesy C&O Canal National Historical Park Headquarters.)

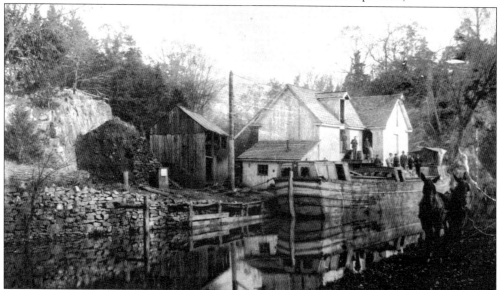

This photo, *c.* 1890, shows Abe Roth's warehouse along the C&O Canal in Pinesburg, Maryland. At the far right of the photo two mules are engaged in their task of pulling the canal barge. The canal mule could pull twice the load of a comparable size horse and worked two six-hour shifts every 24 hours. The mule was relatively small, about 12 to 14 hands high, allowing him to fit into the stable quarters on board. (Courtesy Washington County Historical Society.)